If the Paintings Could Talk...

Michael Wilson
with a foreword by Andrew Marr

NATIONAL GALLERY COMPANY, LONDON
DISTRIBUTED BY YALE UNIVERSITY PRESS

All photographs © The National Gallery 2008, except: 53, 105, 163, 166
p. 53: Henri Matisse, *Portrait of Greta Moll*, 1908. © Succession H. Matisse / DACS 2008
p. 105: Filippo Lippi, *The Vision of Saint Augustine*, about 1452–65,
State Hermitage, Saint Petersburg. © akg-images
p. 163: Sir John Tenniel, 'Alice and the Duchess', 1865.
© Mary Evans Picture Library
p. 166: Edouard Manet, *At the Café*, 1878. Oscar Reinhart Collection, Winterthur,
Switzerland. © akg-images

First published in Great Britain in 2008
by National Gallery Company Limited
St Vincent House · 30 Orange Street
London WC2H 7HH
www.nationalgallery.co.uk
ISBN: 978 1 85709 425 5
525528

British Library Cataloguing-in-Publication Data.
A catalogue record is available from the British Library.
Library of Congress Control Number: 2008920589

Publisher: Louise Rice
Editorial team: Alysoun Owen and Claire Young
Quotes editor: Elizabeth Knowles
Production: Jane Hyne and Penny Le Tissier
Designed by Smith and Gilmour, London
Printed in Great Britain by Butler Tanner & Dennis

The editors thank Jill Laidlaw, Ed Sowerby and staff at the National Gallery,
London for their guidance, ideas, photography and assistance.

Front cover: Frans Hals (about 1580?–1666), *Young Man holding
a Skull (Vanitas)*, 1626–8 (detail)

Contents

Foreword 4
Andrew Marr

If the Paintings Could Talk . . . 6
Michael Wilson

A–Z 8

Index of Artists **173**
Index of Paintings **175**

Foreword Andrew Marr

The National Gallery is not a national gallery. It is certainly not national. Its glories include the work of some British artists, certainly, but most of what will delight you here is the work of Italian, French, German, Flemish or Spanish hands. Many of them worked before the idea of 'nation' was properly established. All the word 'national' means here, is that this is the best collection of art from our peninsula and archipelago, a place called Europe, that can be seen free of charge by people in Britain. What about 'gallery'? A gallery is a covered place for walking. Though walking through the National Gallery is certainly part of the experience, walking is absolutely not the point. Everything important here happens when you stop walking. This is a place for standing, or sitting, still, in front of an image that will – if you give it time, attention and respect – seep into your mind and make living a little better. Let us readily admit that 'peninsular meditation-hub' does not have quite the same ring. But that's what this elegant, familiar, extended sprawl of rooms really is.

Here are some of the most skilfully made, inspiring, daring and buzzingly beautiful images ever made. They are here for us. We do not need to pay to see the main collection. We do not need to queue. Rich people and shrewd people, who bought them long ago, have handed them over or else they have been bought on our behalf. The government makes much of their 'educational value' and you will find children on the floor with crayons and a harassed teacher, as well as illuminating talks for adults in front of particular pictures. Good. But for me, educational value sounds a little grim. I come here, and have done for thirty years, for utter self-indulgent delight – to be transported to the still centre of the turning world, a courtyard in Delft, or sniff long grass with Van Gogh, or fall half in love with a long-dead girl in a silk dress or just shake my head with disbelief at what Leonardo could do with chalk, and Velázquez with melting dribbles of paint. Centuries shrivel and laughing strangers catch our eye. The minute it feels like a classroom, run away fast for fresh air or a sly beer. We must love these pictures – not all, because we have different tastes and prejudices. But they are openings

into the world we can't afford not to try. The art world can be – there is no polite way of saying this – snotty. This book offers us openings into the openings. Here are the stories behind the pictures.

They range from tales of fanaticism, to venereal disease, artist's obsession with hard-boiled eggs, forgery, Nazism, second thoughts, violence, love, a fly you want to brush off and the difficulties of painting in the wind on a beach. What unites them is that they treat the paintings as real, fragile things, made by real people and collected in London by chance and good luck, rather than as mysterious objects of worship. Here are some of the best things humans have ever made. You don't need a special language or a degree. You just need a pair of eyes and a few free minutes.

Introduction Michael Wilson

Looking at paintings in the dignified rooms of the National Gallery can give the misleading impression that over the centuries since they were made they have led an uneventful existence, that they exist simply to be admired and to play their part in the story of the development of western art from Giotto to Cézanne. This book is designed to dispel that myth and tell some of the extraordinary stories that lie behind the pictures, their origins and their meanings. It is something of a miracle that some of them are here at all. Many works of art have not been so lucky and have fallen victim to flood, war and neglect. The paintings featured here are survivors and each one has its own story to tell – a secret life that is often hidden from us when we see a painting in a gallery or a book. Paintings bear witness to the lives of the people who made them and owned them, and their stories are full of incident. The very act of creation might have been tortuous for the artist and the patron and involved false starts and revisions. Then each painting has taken its chances as it has passed from hand to hand over the years. As the stories in this book reveal, some of the paintings we now value and admire have not always fared well: Cima's altarpiece was submerged in a flood, Manet's *Execution of Maximilian* was cut up into pieces. Others have been altered in surprising ways to suit prevailing taste.

But the paintings have also touched and affected lives. Many were made to commemorate real people and are a testimony to their personalities, interests and affections. Among the characters that have played a part are eccentrics and charlatans, as well as discerning patrons and artists of genius. Some paintings have been admired and imitated by other artists or preserved by loving collectors. Rembrandt based his self portrait on Titian, and George Beaumont could not bear to be separated from his favourite Claude landscape. That they are now part of the National Gallery Collection does not make the paintings immune to events. These have been acts of vandalism as well as great achievements of restoration and scholarship, and the occasional touch of farce – such as when a schoolgirl spotted a Van Gogh hanging upside down.

The secret lives of the paintings have to be teased out. Through painstaking sifting through the evidence of the past and in-depth examination of the paintings themselves, remarkable discoveries have been made and continue to be made. Modern techniques of technical examination using infrared or X-ray imaging and analysing the artist's materials have revealed much about how the paintings were created and sometimes changed by later hands. They have brought to light drawing and underpainting hidden from view by subsequent paint layers, telling us much about the artist's initial thoughts. We can admire drawings by Raphael and Leonardo that have not been seen since the artists themselves painted over them, and look at a discarded portrait on top of which the Le Nain brothers painted another picture. Even now, when the days of masterpieces found in attics seem long past, lost paintings are still discovered. Raphael's *Madonna of the Pinks* was found at Alnwick Castle, where it had had long been considered just a copy, and the missing part of an early Umbrian diptych was recently identified and reunited with its sister panel. New and fascinating information has also come to light. We now know that Uccello's *Battle of San Romano* wasn't made for the Medici family as was long thought, but forcibly taken by them from another Florentine family and in the process chopped down to its present shape and size.

This book is not a conventional art history. It doesn't attempt to give a full account of each picture's origin, subject and significance. It would take many volumes to do so and that information can be found elsewhere. As is hinted at by the title, it tries to tell something of a painting's story as if from its own point of view – the people and places it has seen, the circumstances that have shaped it and the incidents that have befallen it. These stories can be surprising, enlightening or just amusing. But they all tell us something more about the pictures and the fascination they hold. They will, I hope, encourage everyone to go back and look at the paintings again with new eyes.

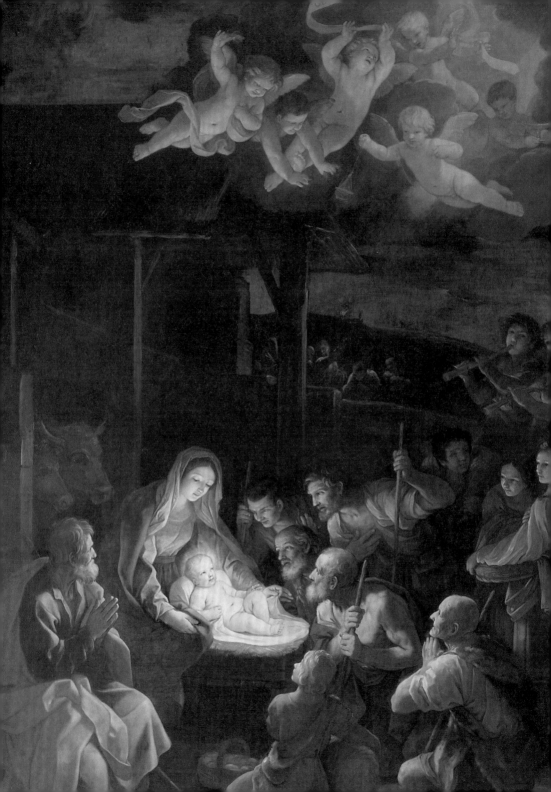

Aerodynamic, Anonymous, Apocalypse…

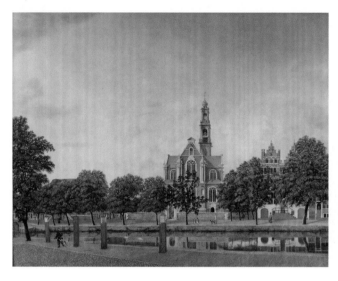

Absence

JAN VAN DER HEYDEN, VIEW OF THE
WESTERKERK, AMSTERDAM, PROBABLY 1660

The Westerkerk is one of Amsterdam's most historic churches, with the city's highest tower. It was here that Rembrandt was buried in 1669 and Queen Beatrix was married in 1966. The Westerkerk was completed in 1631 and looks much the same today as it did when van der Heyden painted this view of it from across the Keizersgracht canal.

Van der Heyden was a man of many talents. Apart from being a highly accomplished painter of townscapes, he organised the introduction of street lighting in Amsterdam and patented the first fire engine with pump-driven hoses. This technical awareness helped when it came to recreating street scenes such as this. He reproduces the details of brickwork, windows, cobbles and decorative ironwork with extraordinary attention to detail. It is even possible to read the tattered posters that are stuck to the hoardings that protect the young trees in the foreground – one of them announces a sale of paintings. Especially skilful is the way he has painted the reflections of the buildings, giving the suggestion of the glassy smoothness of the canal. Faced with this tour de force of illusionism, it is all the more astonishing to discover that the various people who promenade along the further bank and the two swans on the water have no reflections (above). It is as if we had suddenly stumbled into a painting by Magritte in which the laws of nature do not hold. It is inconceivable that so conscientious an artist as van der Heyden could have been so careless – perhaps he left the painting of the figures to another artist.

▶ SEE GENIAL COMPANIONS, GRAFFITI

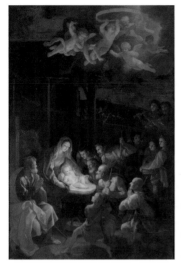

Aerodynamic

Aerodynamic

GUIDO RENI, THE ADORATION OF THE
SHEPHERDS, ABOUT 1640

Reni's *Adoration of the Shepherds* is the
largest painting in the National Gallery.
It fills 15 square metres of canvas and is
as big as a sail. Its aerodynamic qualities
were tested in 1957 when it was being
considered as a purchase by the gallery.
It then formed part of the collection
of the Prince of Liechtenstein and was
housed in his castle at Vaduz, which
occupies a commanding position, high
on a hill overlooking the town. When
a delegation from the gallery went
to consider the painting for potential
acquisition, it was taken outside so
that it could be properly examined in
natural light – with almost catastrophic
consequences. Once in the open air,
the huge canvas was caught by the wind
and drifted off towards the precipitous
drop to the valley below. By good
fortune, the wind dropped in time

and the picture came safely to rest
among the bushes, merely sustaining
some minor punctures. These were
subsequently patched when the picture
arrived at the gallery in London, where
it is well-protected from the elements.

▶ SEE FORGOTTEN, LIGHT OF THE WORLD, VISION

Anatomy

ROSA BONHEUR AND NATHALIE MICAS,
THE HORSE FAIR, 1855

There is only one work by the animal
painter Bonheur in the National
Gallery: a replica of her most famous
painting, *The Horse Fair*, made with the
assistance of her friend and companion
Micas. The original painting, now in the
Metropolitan Museum in New York, is
a vast canvas measuring 2.5 × 5 metres –
a remarkable achievement, especially for
a woman artist working in nineteenth-
century France, but then Bonheur was
a remarkable person. She came from a

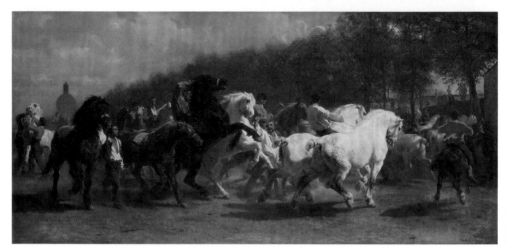

family of artists and from the age of 12 was trained by her father. By 14 she was copying in the Louvre in Paris. In her ambition to become an animal painter, she made numerous sketches of domestic animals, and studied animal anatomy and osteology by visiting the Paris abattoirs and by performing dissections of animals at the National Veterinary Institute. In order to work without drawing attention to herself in the masculine environment of the Paris horse market, Bonheur obtained official permission to wear men's clothes, which she continued to do throughout her working life. Together with her penchant for smoking cigarettes and living with female companions, this gave rise to insinuations about her private life which she vigorously rebutted. Of her preferred style of dress she said, 'I was forced to recognise that the clothing of my sex was a constant bother. That is why I decided to solicit the authorisation to wear men's clothing from the prefect

of police. But the suit I wear is my work attire and nothing else. The epithets of imbeciles have never bothered me.'

▶ SEE HERO WORSHIP, THOROUGHBRED

Anonymous
HANS HOLBEIN THE YOUNGER, CHRISTINA OF DENMARK, DUCHESS OF MILAN, 1538

A mystery surrounds Holbein's portrait of Christina of Denmark and it has nothing to do with the Duchess herself, with Henry VIII, for whom it was painted, or with the artist. This great painting, Holbein's only full-length portrait of a female sitter, was very nearly sold abroad in 1909. It had been on loan to the National Gallery for nearly 30 years when its owner, the Duke of Norfolk, was offered £61,000 for it, a price 'far in excess of its real value' as he put it. It was impossible for the gallery to match that figure within the time granted and it was sold to the

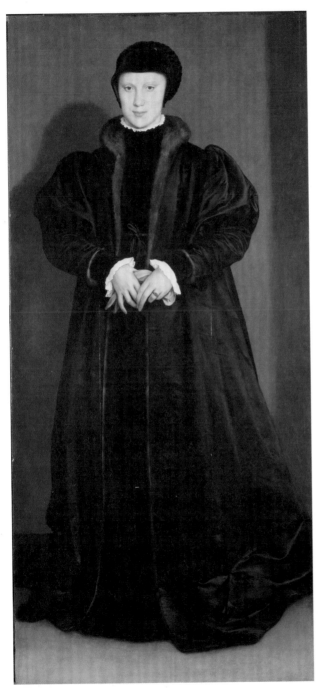

Anonymous

The most
excellent painter
and limner … the
greatest master
truly in both those
arts after the life
that ever was.

Nicholas Hilliard on Holbein

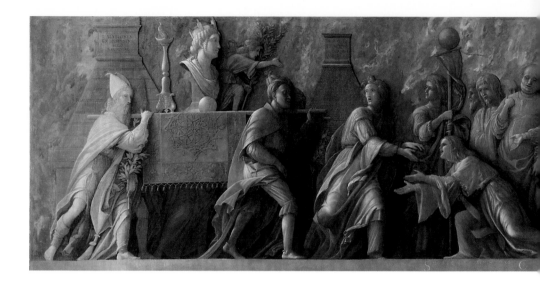

dealer Colnaghi. Within a few days, on 5 May, Colnaghi offered it to the gallery for £72,000, giving a deadline of 1 June. The National Art Collections Fund launched an appeal but the perception that a member of the aristocracy and an art dealer would profit if they succeeded in raising the money hampered their efforts. On 1 June, £40,000 was still needed and it seemed that nothing could stop the painting from going abroad, most probably to Henry Clay Frick, the New York collector. However, that very afternoon an anonymous English woman telegraphed from a 'German watering place' where she was staying and declared: 'I will make up deficiency for the Holbein.' The painting was saved. Her condition was that her identity should never be revealed.

▶ SEE FEATHERS AND FUR

Antiquity

ANDREA MANTEGNA, THE INTRODUCTION OF THE CULT OF CYBELE AT ROME, 1505–6

An obsessive interest in stone seems to permeate the pictorial world of Mantegna. In his *Agony in the Garden* (p. 88), the city of Jerusalem, with its pink stone towers and castellated walls, sits in an arid landscape of striated rocks and towering mountain peaks. The palatial settings of his frescos are adorned with marble, alabaster, porphyry and other exotic stones. And in the background of one picture he even shows quarrymen at work. In another group of works, including this depiction of the cult of Cybele, he paints the figures in monochrome, suggesting carved stone, and the backgrounds like coloured marble. These paintings imitate the appearance of antique cameos, in which the top monochrome layer of a piece of stone (usually a kind of agate) is cut away to reveal a coloured lower layer.

Mantegna was inspired by a passion for the antique world. He would go on jaunts into the countryside to study the remains of classical architecture and copy old inscriptions. He is even said to have held Roman picnics. His foster-father, Squarcione, attacked him for believing that 'the statues of antiquity were more perfect . . . than anything in living nature', and criticised his style for being 'quite sharp and suggestive of stone rather than living flesh'. But his remarks are those of a jealous teacher who could not bear to see himself outclassed by his gifted pupil.

▶ SEE IN-LAWS

Apocalypse

SANDRO BOTTICELLI, 'MYSTIC NATIVITY', 1500

This is no ordinary nativity scene. It is rooted in the violence and upheaval that had overtaken Florence at the moment Botticelli painted it and is concerned as much with things to come as with the events of Christ's birth.

The clue to the painting's meaning can be found in the cryptic Greek inscription at the top. In translation it reads:

This picture, at the end of the year 1500, in the troubles of Italy, I, Alessandro, in the half-time after the time, painted, according to the 11th [chapter] of Saint John, in the second woe of the Apocalypse, during the release of the devil for three-and-a-half years; then he shall be bound in the 12th [chapter] and we shall see [him buried] as in this picture.

The 1490s were a period of war and turmoil in Italy and, as the half-millennium approached, there were widespread fears that the world was about to come to an end. The French had invaded Naples and Milan, and the ruling Medici family had been expelled from Florence, where a pro-French republic was established. The people

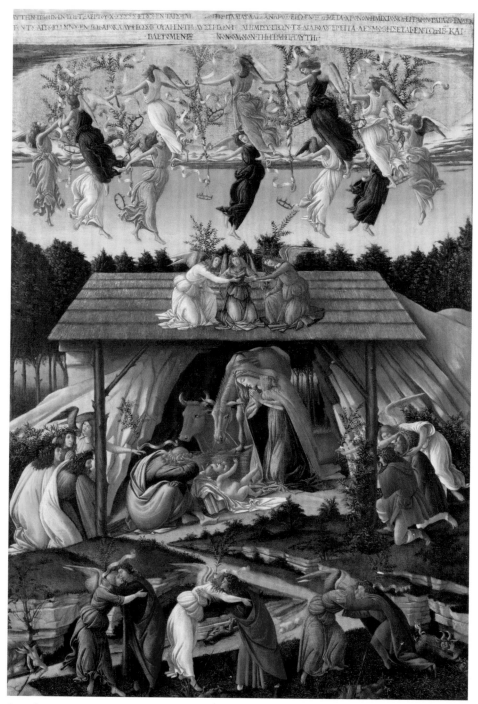

Apocalypse

> Vanity of vanities, saith
> the Preacher, vanity of
> vanities; all is vanity.
>
> Ecclesiastes 1. 2

of Florence were persuaded by the charismatic preacher Savonarola that their misfortunes were the judgement of God for past profligacy. Under his influence, taverns were closed, gambling banned, and luxury goods – including paintings, books and statues – cast onto bonfires.

Botticelli was captivated by Savonarola's preaching, as this painting shows. The inscription is prophetic. It refers to the New Testament book of Revelations, or the Apocalypse, and relates the troubles of Italy to the eleventh chapter, which speaks of the Holy City being besieged for three-and-a-half years and the devil being unleashed. The picture looks forward to the second coming of Christ, and the defeat of the devil, as recounted in the twelfth chapter.

So what we are witnessing is not only the historic birth of Christ as told in the Gospels, but the inauguration of a new era of peace on earth. In celebration of Christ's coming, angels and men clutch branches of olive – a symbol of peace – and horned devils scuttle back into their holes. In the sky 12 angels each carry an olive branch with a crown and a scroll with a Latin inscription. This corresponds to a vision seen by Savonarola in which an allegorical crown consisting of 12 prayers (the text on the angels' scrolls) was offered to the Virgin by the people of Florence.

But Botticelli's vision of peace and harmony was soon confounded by events. Savonarola's criticism of the Church led to his excommunication by the Pope, the authorities in Florence turned against him, and in 1498 he was arrested, hanged and burned as a heretic.

▶ SEE FAMILY FIRM, FORGOTTEN, PALE IMITATION

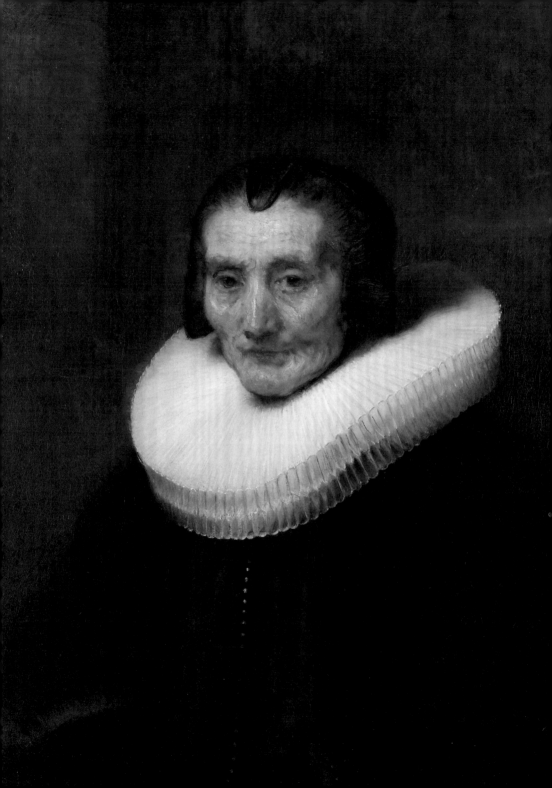

B

Beards, Bombproof, Brothers...

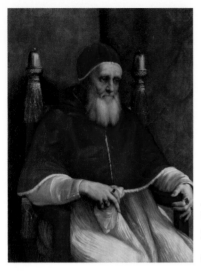

Beard for Bologna

Beard for Bologna
RAPHAEL, POPE JULIUS II, 1511

The Italian writer and painter Giorgio
Vasari wrote of this portrait that it
'caused all who saw it to tremble as
if it had been the living man himself'.
If Pope Julius II's reputation as a ruthless
politician and military strategist wasn't
daunting enough, perhaps his beard
helped. Although he is nearly always
depicted as bearded, Julius II only
actually wore a beard from June 1511
to March 1512, as a sign of mourning
for the loss of the city of Bologna. For a
Pope to wear a beard was unprecedented.
None had done so since antiquity and
the practice had been banned since the
thirteenth century. But, following the
example set by Julius II, Pope Clement
VII grew a beard after the sack of Rome
in 1527, and thereafter all popes wore
beards until the death of Pope Innocent
XII in 1700. This painting forged a new
approach to papal portraiture in other
ways too. Julius is shown in reflective
mood, thoughtful and absorbed: a far
more intimate depiction of such a
powerful sitter than had been seen before.

▶ SEE MUGSHOT, NUMBER 1

Behind Closed Doors
GENTILE BELLINI, CARDINAL BESSARION WITH
THE BESSARION RELIQUARY, ABOUT 1472–3

Bellini's painting records an
extraordinary man and a remarkable
gift. At the right of the painting are
two keyholes, which give a clue to the
picture's original function. It was made
as the door of a tabernacle which housed
the elaborate reliquary depicted here.
This reliquary contained fragments of
the True Cross and was decorated with
Byzantine paintings. It was given by
Cardinal Bessarion to the Scuola della
Carità in Venice (now the Galleria
dell'Accademia) in 1472, where it
remains to this day.

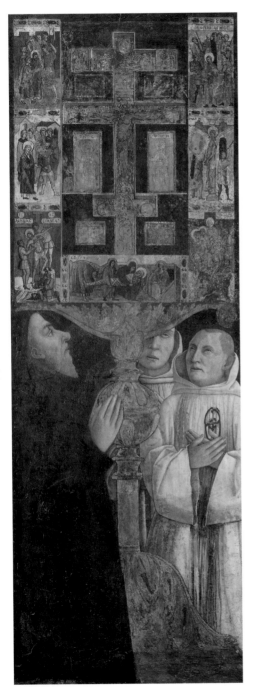

Bellini was presumably asked to paint the tabernacle soon after the presentation of the reliquary, and he has included Cardinal Bessarion at the bottom with two members of the Confraternity. Bessarion was a Greek who was first sent to Italy by the Emperor John VIII Palaeologos to plead for support in Constantinople's final struggle against the Ottoman Turks. Although he failed in his mission, he stayed in Italy where he was made a Cardinal and Patriarch of Constantinople. He gave his library of Greek manuscripts to the city of Venice and in 1463 presented his reliquary, reserving its use for his lifetime. In May 1472, when leaving Rome for France, Bessarion transferred the precious object to Venice where it was installed with great ceremony in the Scuola.

▶ SEE RESCUED

Behind Closed Doors

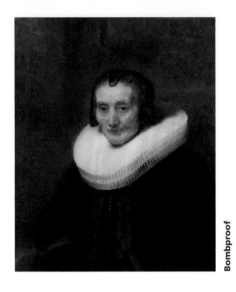
Bombproof

Bombproof

REMBRANDT, MARGARETHA DE GEER, WIFE OF JACOB TRIP, 1661

Late in 1941, after London had been devastated by the Blitz, a new arrival joined the National Gallery's paintings. Rembrandt's bust-length portrait of Margaretha de Geer, with her wrinkled face, in her black cap and starched ruff, was bought by the National Art Collections Fund and presented to the gallery. It joined the collection deep underground in a quarry in Wales, where the paintings had been stored to protect them against German bombs. A disappointed member of the public wrote to The Times with a plea: 'Like many another one hungry for aesthetic refreshment, I would welcome the opportunity of seeing a few of the hundreds of the nation's masterpieces now stored in a safe place. Would the Trustees of the National Gallery consider whether it were not wise

and well to risk one picture for exhibition each week?' After lengthy consideration the Trustees decided to bring Margaretha to London where she was shown in splendid isolation in the stripped galleries. Arrangements were made to have her carried to a cellar each night and whenever the air-raid sirens sounded. 'Large crowd to see the Rembrandt' reported The Times on 20 January 1942, the day after she was out on display. She was the first of a series of 'Pictures of the Month' that were sent to brave the bombing and provide cultural sustenance to Londoners deprived of art. Long queues of visitors waited to take their turn in front of the chosen painting, often many more than had visited the gallery on a daily basis in peacetime. One grateful visitor from Cardiff wrote to the Trustees: 'I could enjoy them better one at a time, and then, if I might put it, thro the wrong end of a Telescope, so that as I came

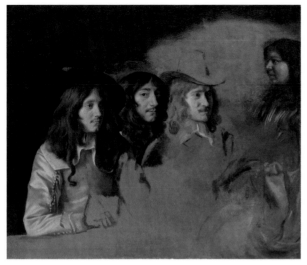

Brothers

to understand I could gauge and alter them to my own liking.'

► SEE GENIAL COMPANIONS, GREAT ESCAPE, OFF-BALANCE

Brothers

LE NAIN BROTHERS, THREE MEN AND A BOY, ABOUT 1647–8

This painting is full of mysteries. Until it was cleaned in 1968, it was known as *A Trio of Geometers*, because of the globe and mathematical instruments that until then were shown at the right of the picture. But it was discovered that these were later additions by a different artist, and when they were removed, two unrelated studies of a boy's head and some clothing, possibly a sleeve, were revealed. The portrait of the three men was also found to be unfinished.

The painting has long been associated with Antoine, Louis and Mathieu Le Nain, three artist brothers who were received into the French Academy of Painting in 1648, and it is tempting to think that this picture could be a portrait of all the brothers, made by one of them. What lends force to this theory is the fact that the central head has clearly been added after the other two – the artist has left no room for his body and the head is uncomfortably squeezed in. And while the two flanking figures look to the right in the direction they are facing, the one in the middle looks out at the viewer, as he would if the artist was painting his own likeness in a mirror.

► SEE CONSERVATION, HAT TRICK, X-RAY

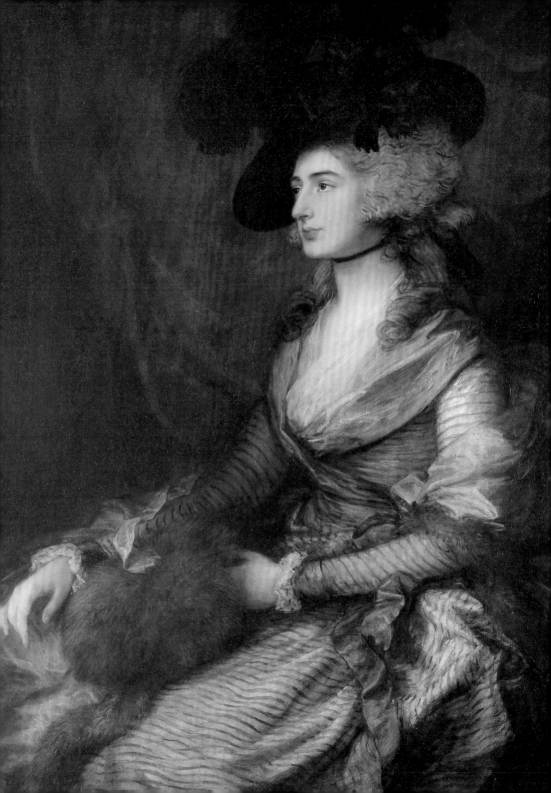

C

Celebrities, Codes, Comeback …

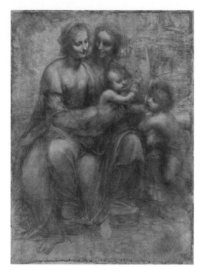

Cartoon

LEONARDO DA VINCI, THE VIRGIN AND CHILD
WITH SAINT ANNE AND SAINT JOHN THE BAPTIST,
ABOUT 1499–1500

A question that many visitors must
silently formulate but never dare to ask
is 'what is funny about the Leonardo
cartoon?' This sublime drawing
certainly has little in common with the
cartoons we know today. The word
'cartoon' comes from the Italian *cartone*
meaning paper, and was used in the
sixteenth century to mean a full-sized
preparatory drawing for a painting.
Usually holes were pricked along the
contours of the cartoon and a black
powder was then rubbed or blown
through the tiny holes to transfer the
drawing to the surface to be painted.

The modern usage of the word was
coined by the magazine *Punch* in 1843,
in response to an exhibition of designs,
or cartoons, for decorations for the new
Houses of Parliament. *Punch* published

a series of satirical drawings, which it
ironically termed cartoons, contrasting
the lavish plans for Westminster with
the miserable poverty of London's
population. The first of the drawings,
by John Leech, depicted an exhibition
of opulent portraits visited by a group
of ragged paupers. The caption read:
'The poor ask for bread, and the
philanthropy of the state accords an
exhibition.' The satirical cartoon
was born.

▶ SEE DA VINCI CODE

Celebrity, Georgian Style

THOMAS GAINSBOROUGH, MRS SIDDONS, 1785

For 30 years, from 1782 until 1812,
Sarah Siddons dominated the London
stage as its most celebrated tragic actress,
making the role of Lady Macbeth her
own. The artist Joshua Reynolds
glorified her as the Muse of Tragedy,
while caricaturists poked fun at her

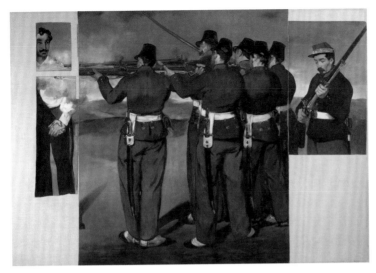

as 'Queen Rant'. Gainsborough took a more individual, less bombastic approach, although producing the portrait was not without its difficulties. The profile caused him much grief, and he is reported to have exclaimed, with a certain ambiguity, 'confound the nose, there's no end to it'.

Siddons became such an icon that, as Gainsborough intimated in this portrait, she could dispense with the trappings of the stage and still be recognised. At her farewell appearance at Covent Garden on 29 June 1812, in the role of Lady Macbeth, the play was brought to a halt at the end of the sleepwalking scene by the roars of the crowd. When the curtains re-opened, she appeared as herself, seated in her own clothes, and made an emotional farewell speech that lasted eight minutes.

▶ SEE DEEP POCKETS, SISTERS

Censorship

EDOUARD MANET, THE EXECUTION OF MAXIMILIAN, ABOUT 1867–8

A patchwork of painted fragments on a bare canvas is not how Manet conceived his monumental picture of the execution of the Austrian archduke, Maximilian, who had been made Emperor of Mexico by Napoleon III. Yet we might not have been able to see these fragments together at all but for the efforts of two artists – Edgar Degas and Howard Hodgkin – both great admirers of Manet.

When, in 1867, Napoleon III withdrew French military support from Mexico, Maximilian was executed by firing squad. Manet, a fervent Republican, painted no less than four versions of the event, as well as producing a lithograph. Mexican soldiers had executed Maximilian but Manet painted the soldiers in French-looking uniforms. Because the French government was implicated in Maximilian's death, Manet was not

allowed to show any of these paintings in France during his lifetime and the lithograph was suppressed by the censors. The National Gallery version languished in a cellar and by the time Manet died in 1883 was already damaged. An old photograph shows that the left part with the Emperor and one of his generals had been cut off, possibly by Manet himself. The rest of the canvas, which was probably suffering the effects of damp, was then cut up. The most damaged pieces were discarded and the surviving fragments sold separately. It was the artist's friend and colleague, Edgar Degas, who decided to buy up what pieces of the painting he could and reassemble them, sticking them down onto a new canvas.

Following Degas's death in 1917, his collection was sold in Paris in March 1918. The government issued a special grant for the purchase of works at the sale, and the National Gallery Director, Sir Charles Holmes, made the hazardous journey across war-torn France, returning with, among other works, Manet's *Execution*. On seeing the patchwork of pieces, the Trustees took alarm and decided that it could not be shown in its fragmentary form. It was dismantled and the four pieces framed and shown separately. They remained apart for over half a century until 1979 when Hodgkin requested that the pieces were again reassembled. Thanks to him, and to Degas, we can admire what has survived of Manet's scathing indictment of Napoleon III's foreign adventures.

▶ SEE INCOGNITO, MELODRAMA, YARN

Chairs
VINCENT VAN GOGH, VAN GOGH'S CHAIR, 1888

An empty chair can be an eloquent symbol of an absent person, its arms, legs and curves in some way embodying the physical presence of its former occupant.

While living at Arles in France with fellow artist Paul Gauguin, Van Gogh painted two pictures of chairs, his own and Gauguin's. The two could not be more contrasting and expressive of the different personalities of the painters. Gauguin's chair is red with sweeping arms and back, and sits on a patterned carpet, some books and a lit candle set on it. It seems to speak of the owner's late nights spent in heated debate. Van Gogh's is a rough peasant chair with a rush seat and a pipe and bit of tobacco resting on it. It speaks of austerity and simple ideals.

The inspiration for these pictures came from Luke Fildes, an English illustrator of, among other things, Charles Dickens's *The Mystery of Edwin Drood*. Shortly after Dickens's death, Fildes was a guest at the novelist's house, Gad's Hill Place, and he decided to sketch Dickens's desk and chair just as they had been left. The engraving, entitled *The Empty Chair,* was published in the 1870 Christmas edition of *The Graphic* and thousands of prints were sold.

Van Gogh suffered from black moods; he smoked a pipe because Dickens recommended it as a cure for melancholy. He hoped that Gauguin would be a companion and share in his artistic adventure in the South of France, but they were temperamentally

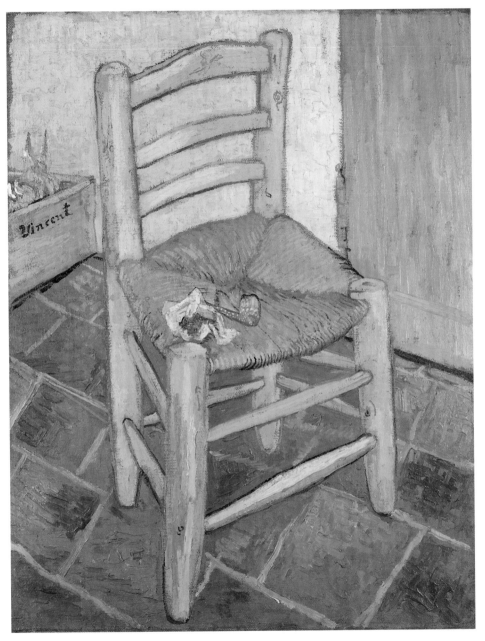

Chairs

> Here is a brain consumed by the fire of a star. It frees itself in its work just before the catastrophe.
>
> Paul Klee on Van Gogh

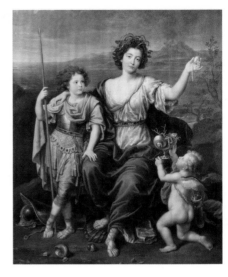

Coded Message

incompatible and their friendship ended in recriminations and the onset of Van Gogh's mental illness. Seen in this light, there is something deeply poignant in Van Gogh's empty chair, which, echoing Fildes's print of Dickens's chair, seems to augur separation and death.

▶ SEE TOPSY-TURVY

Coded Message

PIERRE MIGNARD, THE MARQUISE DE SEIGNELAY AND TWO OF HER SONS, 1691

Why would a French marquise of the seventeenth century, Catherine-Thérèse Goyon de Matignon, widow of Jean-Baptiste Colbert de Seignelay, have herself portrayed as the Greek sea-goddess Thetis? She is sitting by the seashore, her hair draped with seaweed, coral and pearls, with her foot resting on a giant clam shell. One hand holds a cameo showing a portrait of her recently deceased husband, while the other is draped

across the shoulder of her eldest son, Marie Jean-Baptiste de Seignelay, who is dressed as Thetis' son, the Greek hero Achilles. To her left, a winged cupid – possibly a portrait of another of her sons – presents her with a rare nautilus shell brimming with pearls and coral.

The picture is an allegory – an image full of coded messages. At one level the marine imagery can be explained by the fact that the marquise's husband had been Minister for the Navy. But the marriage had been unhappy. Her husband was of inferior social standing, the grandson of a draper (even though his father, Colbert, had been the King's Minister of Finance). Thetis too was married against her will, to the mortal Peleus, who raped her to make her bear their son, Achilles. According to the poet Ovid, it was prophesised that Thetis would be mother to a son who would be greater than his father. She obtained for Achilles armour made by

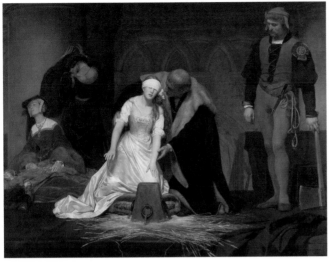

Comeback Queen

the god Vulcan within the fiery crater of Mount Etna (seen smoking in the background of the painting) and dipped him in the waters of the River Styx to make him invincible. Only the heel she held him by remained dry and this proved to be his undoing (his 'Achilles' heel'). The marquise's son, for whom Madame de Seignelay had just purchased a military commission, is shown wearing Achilles' divine armour.

But why should a cupid be shown presenting expensive gifts to the widowed marquise? Is it just that she wanted people to know that she was open to proposals of marriage (provided they were of sufficient distinction)? Or is this a response to the rumours that circulated at the time that she aspired to be mistress to the French king? Perhaps we are to infer that such costly gifts could be the gift of no suitor other than the king, and that she is indeed the royal mistress.

▶ SEE DEATH, HIDDEN MEANINGS, SYPHILIS

Comeback Queen

PAUL DELAROCHE, THE EXECUTION OF LADY JANE GREY, 1833

Delaroche was a celebrity artist. In the Paris of the 1830s his paintings had much the same appeal as the movies of Steven Spielberg do today. When *The Execution of Lady Jane Grey* was shown at the Paris Salon in 1834, barriers had to be erected to restrain the crowds who flocked to see it. The painting was bought by the great Russian collector Prince Anatole Demidoff and admired by Queen Victoria. But, like other things Victorian, narrative painting designed to pull at the heart strings fell out of fashion in the twentieth century.

After the painting was left to the National Gallery in 1902, it became something of a white elephant, neither serious Old Master painting nor modern French work in the manner of Cézanne or Gauguin. It shuttled between the National Gallery and the Tate Gallery

until it fell victim to the Thames flood of 1928 and was declared a 'total loss'. Almost half a century passed before it was rediscovered in 1973, rolled up in the basement of the Tate. The damage had been exaggerated and the painting was returned to the National Gallery and restored. But then what? The painting had to be shown, but the only way to make it 'palatable' was to do so in the context of a temporary exhibition linking Delaroche with the more highly regarded poet and critic Théophile Gautier. 'The aim of the exhibition is not to rehabilitate Delaroche's reputation,' wrote the curator. 'The only question concerning him which is likely to interest the current generation is just why was he so successful in his lifetime.' Imagine the curator's consternation when the public greeted the picture with as much the same enthusiasm as when it was first painted. Delaroche's time had come again. Once it had been shown, the painting could not be relegated to the basement 'reserve' and took its place on the main floor where it continues to thrill and fascinate gallery visitors.

▶ SEE EXECUTION, FRAMED, LOWERING THE TONE

Conservation

FOLLOWER OF ROBERT CAMPIN, THE VIRGIN AND CHILD BEFORE A FIRESCREEN, ABOUT 1440

When this picture was cleaned in 1992-3, the conservators at the National Gallery faced a dilemma. The main part of the panel dates from about 1440 and is by a follower of the Netherlandish painter Robert Campin. But there is a strip 9 cms wide down the right-hand side, which includes the cupboard and the chalice, and a strip 3 cms wide along the top, down to and including the cross bar of the window, which were added in the nineteenth century. In all probability the restorer was replacing parts of the original panel that were damaged. But as he repainted it, the top of the fireplace makes no structural sense, and the cupboard seems to be his own invention. A late fifteenth-century version of this composition shows a much plainer cupboard and chalice.

So what should a modern conservator do – remove the additions, disguise them in some way or leave them as they were? Since no one can be certain what was painted originally, it would seem wrong to replace one invention with another. And to remove parts of the picture, which at least give some indication of how it might have looked, would have been carrying purism to extremes. The solution adopted was to keep the nineteenth-century additions but to give them a slight brownish tint to differentiate them, so that it is obvious to any close observer that they are not part of the original painting.

▶ SEE HAT TRICK, SOAKED

Conservation

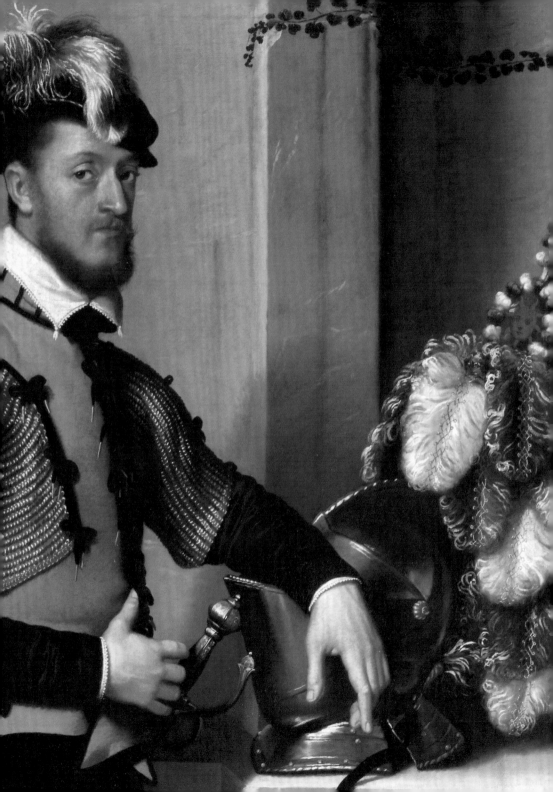

D

Death, Diplomacy, Distortion …

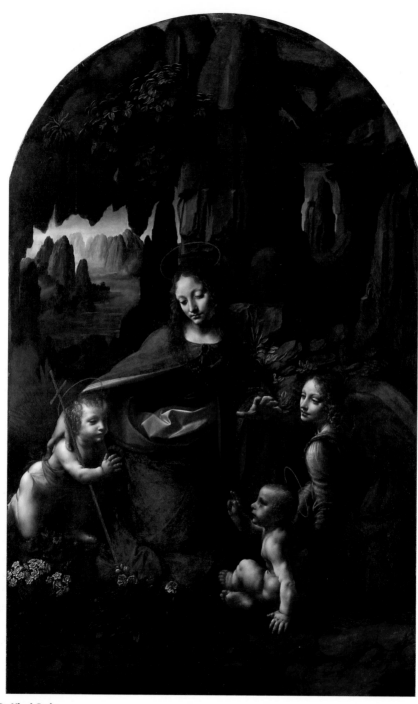

Da Vinci Code

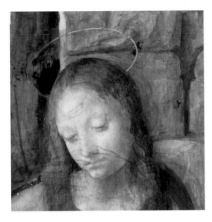
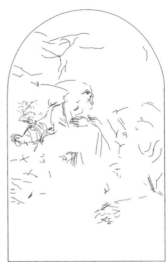

Da Vinci Code

LEONARDO DA VINCI, THE VIRGIN OF THE
ROCKS, ABOUT 1491–1508

There are two versions of Leonardo's *Virgin of the Rocks*: one here, in the National Gallery, and one in the Louvre in Paris. Their relationship has long been debated. It seems that Leonardo was commissioned to paint an altarpiece by the Confraternity of the Immaculate Conception in Milan in 1483, but when they failed to give him a big enough bonus, he sold it. He then painted another version (the National Gallery one), which was delivered to the Confraternity in 1508, with some details still unfinished. This sequence of events has been thrown into question by the discovery that under the paint of the National Gallery picture is a drawing for a different composition. When experts used infrared reflectography to examine the picture (above left), they were amazed to find an image of a kneeling woman with downcast gaze, which doesn't correspond to anything in the painting. Her head is positioned just above the Virgin's, where there are only rocks in the final composition, and her hand is underneath the Virgin's face. The curator and conservators were so astonished they had to 'go away and sit quietly for a bit to get our thoughts in order'. What the discovery means is still uncertain. Did Leonardo plan to paint a new and different composition for the Confraternity, possibly of the Virgin adoring the infant Jesus, rather than just reproduce his earlier version? Did the Confraternity then insist on a copy of the earlier picture? Or was it quicker and easier for Leonardo to revert to the earlier design? What is clear, though, is that the drawing is in effect a new Leonardo (see reconstruction above right), unseen since it was painted over years.

▶ SEE X-RAY

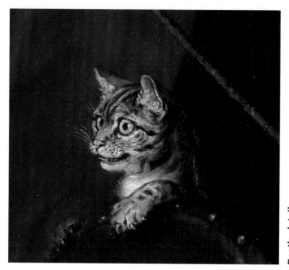

Death, detail

Death

WILLIAM HOGARTH, THE GRAHAM CHILDREN, 1742

In spite of the smiling faces and chubby cheeks, there is a dark undercurrent to this portrait of the children of Daniel Graham, Apothecary to King George II. On top of the clock on the left, itself a reference to the passing of time, is a golden figure of cupid holding a scythe, and beside him there's a tiny hourglass; the scythe and the hourglass are symbols of death. On the right a cat stares with hungry eyes at a caged bird, eager to cut short its life. Even the music from the organ (which will eventually stop), played by grinning Richard Graham, and the gleaming fruits in the bowl (which will rot) are symbols of the brevity of life and its pleasures. But why did Hogarth put such morbid references into a picture that, at first glance, looks like a celebration of robust and spirited youth? The youngest of the Graham children, little Thomas in his skirts and bonnet, shown seated in an eighteenth-century pram, had died even before the painting was completed.

▶ SEE CODED MESSAGE, HIDDEN MEANINGS, SISTERS

Deep Pockets

THOMAS GAINSBOROUGH, DR RALPH SCHOMBERG, 1770

This portrait may well have been painted to pay the doctor's bill. When he was living in Bath, Gainsborough asked Dr Ralph Schomberg to attend his daughter Mary who was suffering from a mysterious recurrent illness, which other physicians claimed was hereditary and untreatable. Schomberg diagnosed a 'delirious fever' and appeared to cure her. Gainsborough expressed his gratitude by painting this affectionate portrait.

Schomberg was the son of a Jewish doctor who settled in England and

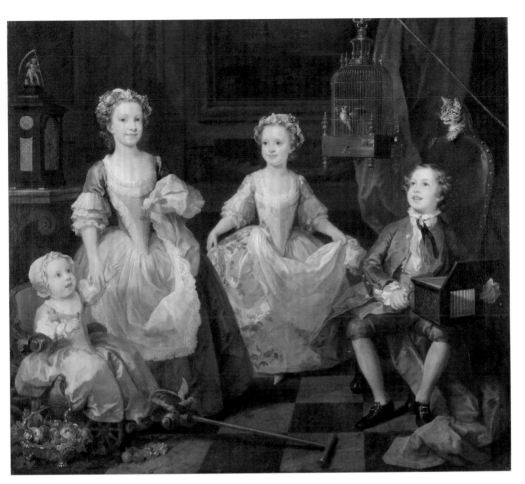

Death

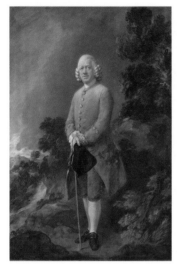

Deep Pockets

made his sons renounce the Jewish faith – which allowed them to pursue public careers. He practised in Bath for about ten years, attending Gainsborough and his family. In this portrait, his capacious pocket turns out to be an unintended comment on the doctor's character. As a young man, he was constantly short of money, and after suing his father for a fictitious debt, he was cut off without a shilling. His final fall from grace came in 1777, when he was discovered to have stolen money from a church collection in aid of the Bath hospital. 'Above seven pounds in guineas and half crowns were found in his coat pocket when he was charged with the fact.' He left Bath in disgrace and settled in Reading where he died in 1792.

▶ SEE SISTERS

Diplomacy

PETER PAUL RUBENS, PEACE AND WAR, 1629–30

Rubens was a diplomat as well as an artist. He was a close and trusted adviser of Isabella, Regent of the Spanish Netherlands, and when war broke out between Spain and England she asked him to negotiate a peace settlement. He went first to Madrid where the Spanish king, Philip IV, and his minister, Count-Duke Olivares, were so impressed by his grasp of the complicated negotiations that they agreed to send him to London. Rubens arrived in England in June 1629 and met Charles I at Greenwich. The king, who already owned a self portrait by Rubens, welcomed the arrival of the painter. 'The King is well satisfied not only because of Rubens's mission, but also because he wishes to know a person of such merit,' reported Sir Francis Cottingham, the English representative in the peace talks. The negotiations that followed were protracted and difficult.

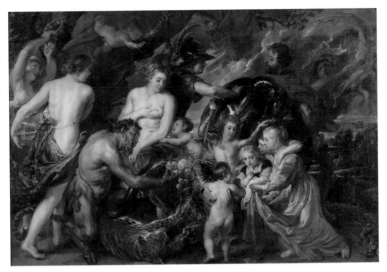

Diplomacy

The envoys of France, Venice and the United Provinces were opposed to the peace and worked hard to prevent it. But ultimately Rubens and Cottingham prevailed. Peace was agreed in principle and a new Spanish ambassador named.

But months went by before the ambassador finally arrived in early 1630, giving Rubens time to see some of the great English art collections and to do some painting. The most important work he produced during his stay in England was *Peace and War*, and it was created as a present from himself to the king to reinforce the peace negotiations. Minerva, Roman goddess of wisdom, shields Peace and her retinue from the threat of Mars the god of war, and two girls are ushered in to share the fruits of peace. Rubens owed this touching detail to his stay in London. The two girls in contemporary dress and the figure of Hymen, holding a torch, are portraits of the children of his host in London, his friend and compatriot, Balthasar Gerbier.

▶ SEE HERO WORSHIP, JIGSAW, RESPECTFUL DISTANCE

Distortion
CAREL FABRITIUS, A VIEW OF DELFT, WITH A MUSICAL INSTRUMENT SELLER'S STALL, 1652

Among the National Gallery's Dutch pictures is this very strange view of Delft by Fabritius. A tiny canvas, of unusually wide format, it shows the exterior wall of a tavern with a seated man and some musical instruments. On the right a canal, a church and a curving street can all be seen. But the whole composition doesn't seem to hold together. The left and right sections seem curiously flat and the musical instrument (a viola-da-gamba) in the foreground is abruptly cut off at the bottom.

But this is not how Fabritius intended the picture to be viewed. This painting

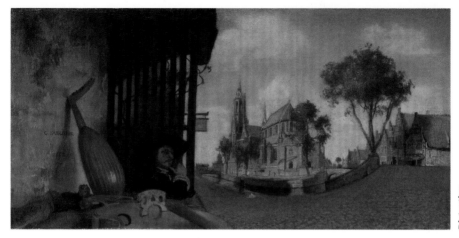

Distortion

once formed part of a 'perspective box' that people could look into through a peephole. The English diarist John Evelyn described seeing just such a box in 1656: 'Was showed [to] me a pretty perspective and well represented in a triangular box, the great Church of Haarlem in Holland, to be seen through a small hole at one of the corners, and contrived into a handsome cabinet.' Fabritius's painting would have been mounted inside such a box on a strongly curved surface opposite the peephole, lit from above through translucent paper. The painting would have also been extended onto the floor of the box, so that the belly of the viola-da-gamba would be visible. A reconstruction of the box was made for a National Gallery exhibition in 2001, showing exactly how effective Fabritius's painting is when viewed under the right conditions. The sides become compressed, correcting the distortion

seen in the flat painting, and the illusion of depth is enhanced. The church appears less squat and the lower part of the viola-da-gamba seems to advance into the viewer's space.

▶ SEE MARTIAL ART, PATIENCE AND MEEKNESS, THUNDERCLAP

Drop-Foot

GIOVANNI BATTISTA MORONI, A KNIGHT WITH HIS JOUSTING HELMET, ABOUT 1554–8

The Italian title of this portrait is 'il cavaliere dal piede ferito', the knight with the wounded foot, referring to the brace on his foot. He may not have been wounded at all, but could have been suffering from a condition known as 'drop-foot', a failure of the ankle muscles due to the inflammation or disease of the muscles controlling them. Why, one wonders, did the knight want to be seen as disabled. Since he is clearly a soldier of sorts – pieces of armour lie

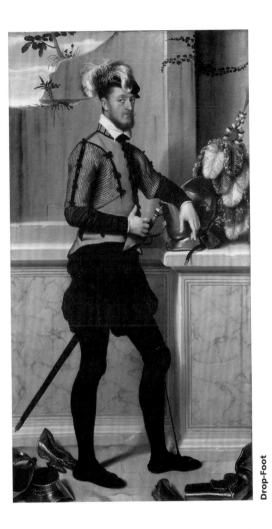

Drop-Foot

scattered at his feet and he rests his arm on a magnificent plumed tournament helmet – it may well be that his condition was thought to be the result of some heroic deed, or that he was considered heroic in spite of it.

The little we know about the sitter suggests that he was no ordinary character. In all probability he is Conte Faustino Avogadro, a nobleman from Bergamo who got caught up in the feuding between the Albani and Brembati families that divided the city in the mid-sixteenth century. With his sideways glance, Faustino has the look of a conspirator, and he was probably implicated in the assassination of Count Achille Brembati in 1563. He was forced into exile in Ferrara and died there a year later, apparently after falling, blind-drunk, into a well.

▶ SEE KINGDOM COME, PURLOINED

Claret is the liquor for boys; port, for men; but he who aspires to be a hero (smiling) must drink brandy.

Samuel Johnson

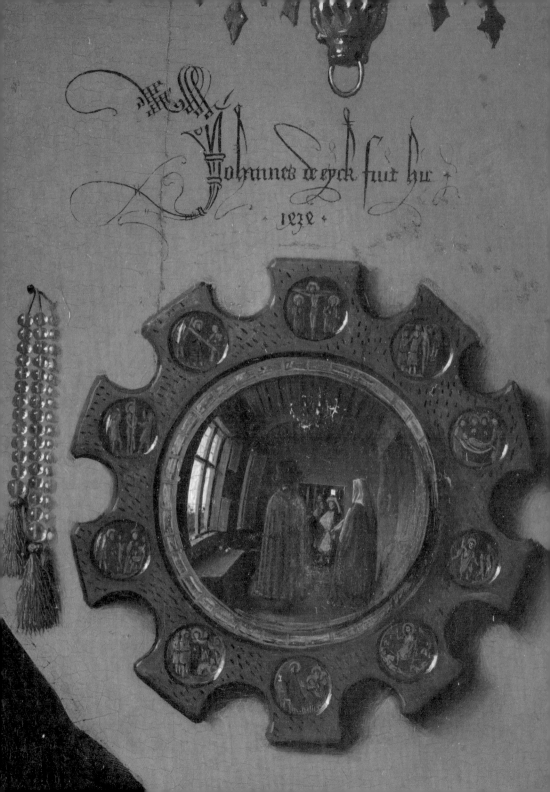

Enigma, Envy, Eyebrows...

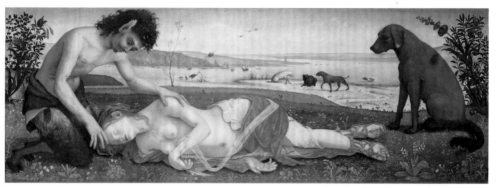

Eccentricity

PIERO DI COSIMO, A SATYR MOURNING OVER A NYMPH, ABOUT 1495

It is apparent from this painting that the artist, Piero, was a lover of animals. On the right a mournful dog looks on as a satyr tends to a wounded nymph, in the background three more dogs nose about, and beyond them various waterfowl feed at the river's edge. According to the writer and painter Giorgio Vasari, who depicts him as a thoroughgoing eccentric, Piero was himself 'more like a beast than a man', who delighted in watching wild animals and refused to prune his fruit trees. His mythological paintings are filled with beasts and wild men, and bizarre hybrid creatures. One series of paintings includes a forest fire raging unchecked, and was probably inspired by the Roman writer Vitruvius' account of the evolution of man, showing the growth of civilisation by the control of fire. Vasari tells us that fire held a particular fascination for the artist. He was frightened of thunderstorms and so pyrophobic that he cooked as little as possible, largely living off eggs which he boiled 50 at a time when he was making up the glue size for his paintings.

▶ SEE QUIXOTIC

Enigma

JAN VAN EYCK, THE ARNOLFINI PORTRAIT, 1434

Just as changing advice about what we should or should not eat and drink has taught us to be wary of the pronouncements of scientists, so we should treat the opinions of art experts with caution. Van Eyck's *Arnolfini Marriage* is a case in point. There have been many, many theories about this painting. For years the picture was thought to be the wedding portrait of Giovanni di Arrigo Arnolfini and his wife Giovanna Cenami. The tiny

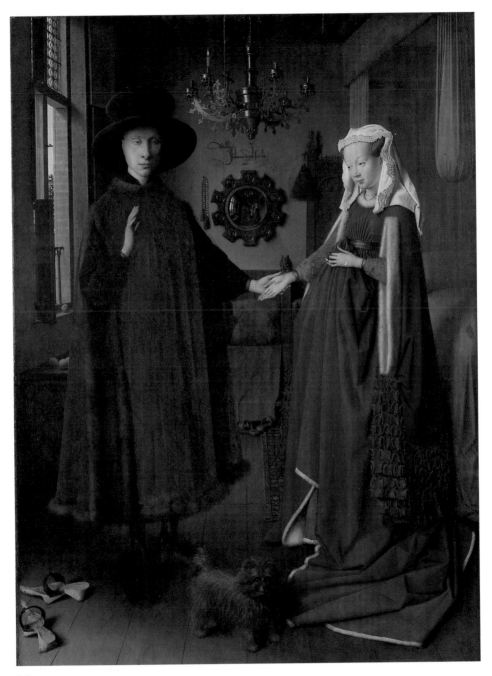

Enigma

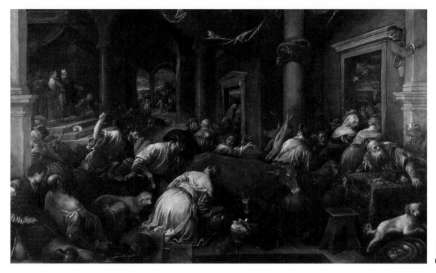

Envy

figures you can see reflected in the mirror were identified as the marriage witnesses, and the artist's signature 'Jan van Eyck was here 1434' was taken to mean that the artist was also a witness to the wedding. But, in 1997, it was proved that this couple were actually married thirteen years after the date on the painting and six years after the painter's death! Some historians propose that this is a picture of Giovanni di Nicolao Arnolfini and his first wife. But his wife had died by February 1433, making this a memorial picture. The lit candle on Giovanni's side may stand for the fact that he has gone on living, while the burnt-out candle on his wife's side could represent her death.

Or the picture may have no meaning at all beyond that of a beautiful double portrait of a married couple.

▶ SEE ILLUSIONIST

Envy

JACOPO BASSANO, THE PURIFICATION OF THE TEMPLE, PROBABLY ABOUT 1580

Any artist working in or near Venice in the sixteenth century must have felt overshadowed by Titian, the most successful artist of the time. His work adorned churches, palaces and public buildings, and he was favoured by kings and princes across Europe. He held on to his dominant position into extreme old age (he may have been over 90 when he died) and, being an astute businessman, amassed a great fortune. He was made a Count Palatine and Knight of the Golden Spur by the Emperor Charles V, who also granted him a generous annuity. Such success inevitably inspired envy as well as admiration. A mixture of both may have prompted the painter Jacopo Bassano to include what seems to be a portrait of Titian as a moneylender in his painting of *The Purification of the Temple*. On the

To draw pure beauty –
shows a master's hand

John Dryden on Titian

extreme right an old bearded man, richly dressed in a fur-lined gown of red and green and wearing a skullcap, attempts to save his table loaded with coins from the press of people and animals being driven from the Temple by Jesus. He bears an uncanny resemblance to a late self portrait by Titian, in which he wears similar furs and a skullcap.

▶ SEE GENIAL COMPANIONS, RESCUED

Execution
MICHELANGELO MERISI DA CARAVAGGIO,
SALOME RECEIVES THE HEAD OF SAINT JOHN
THE BAPTIST, 1607–10

Among Caravaggio's final masterpieces are three disturbing works in which he has shown decapitated heads: *David with the Head of Goliath*, and two versions of *Salome receives the Head of Saint John the Baptist*. In the first work, Caravaggio portrays himself as the victim, his

bearded head held up by the executioner. The National Gallery version of *Salome* focuses on the immediate, pained aftermath of this event, although here, the head of John the Baptist is not literally a self portrait.

No painter has been so notorious for wild behaviour as Caravaggio. 'After a fortnight's work he will swagger about for a month or two with a sword at his side and a servant following him, from one ball-court to the next, ever ready to engage in a fight or an argument, so that it is most awkward to get along with him' is how he was described in 1604. Two years later he killed a man in a fight and was forced to flee Rome, first to Naples, then Malta. He was hoping the Grand Master of the Knights of Malta could help him secure a pardon, but another brawl resulted in his arrest. In December 1608 he was expelled from the Order of the Knights 'as a foul and rotten member'. He

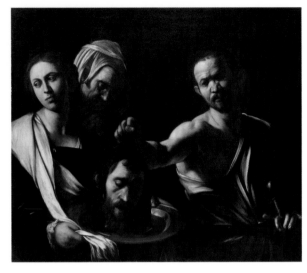

moved on to Sicily and again to Naples, where an attempt was made on his life which left his face disfigured. In 1610 he sailed for Rome with his paintings, hoping to be pardoned by Cardinal Scipione Borghese, but he died of fever on the way.

Perhaps Caravaggio identified with the figure of John the Baptist at a deeper level, and saw violent death as the inevitable – and wished for – conclusion to his own turbulent life.

▶ SEE CARTOON, COMEBACK QUEEN, SKULL

Exiles

CLAUDE MONET, THE THAMES BELOW
WESTMINSTER, ABOUT 1871 (TOP)
CAMILLE PISSARRO, FOX HILL, UPPER NORWOOD,
1870 (CENTRE)
CHARLES-FRANÇOIS DAUBIGNY, ST PAUL'S
FROM THE SURREY SIDE, 1873 (BOTTOM)

A cluster of paintings in the National Gallery bear witness to the fellowship of three painters – Monet, Pissarro and Daubigny – who fled France during the Franco-Prussian War and Paris Commune of 1870-1 to settle in London. It may have been the senior of the three, Daubigny, who introduced Pissarro to the French dealer Paul Durand-Ruel who had a gallery in New Bond Street, and it was Durand-Ruel who put Pissarro in touch with Monet, who was living in Kensington. Pissarro later recalled: 'Monet and I were very enthusiastic over the London landscapes. Monet worked in the parks, while I, living in Lower Norwood, at that time a charming suburb, studied the effects of fog, snow and springtime.' Together they visited the National Gallery where they admired the landscapes of Turner, Constable and John Crome, and it is fitting that the gallery now houses some of their finest London paintings of this period: Monet's *The Thames below Westminster*, Pissarro's *Fox Hill, Upper Norwood* and *The Avenue, Sydenham,*

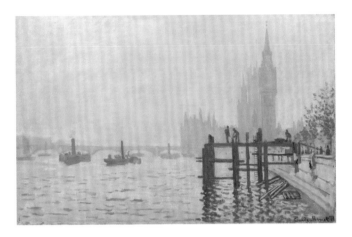

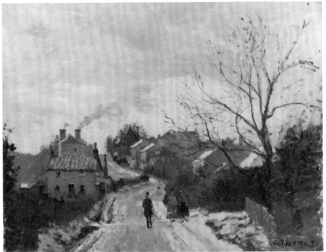

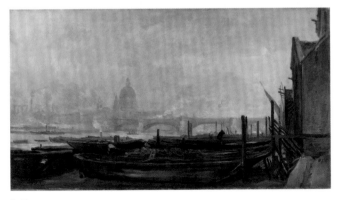

Exiles

> Happy are those who see beauty in modest spots where others see nothing. Everything is beautiful, the whole secret lies in knowing how to interpret it.
>
> Camille Pissarro

and Daubigny's *St Paul's from the Surrey Side*. The latter bears the date 1873 but must either have been begun on the spot and finished in France, or worked up from sketches made in London. Monet and Pissarro were entranced by London and both returned in old age to paint there, Monet drawn again to the river and its bridges shrouded in fog, and Pissarro attracted, as before, to the suburbs with their sprawling houses, railways and allotments.

▶ SEE LAST VOYAGE, RACE

Eyebrows

HENRI MATISSE, PORTRAIT OF GRETA MOLL, 1908

It is not always easy to like the way an artist has painted you, even when that artist is as great as Matisse. Greta Moll was a painter herself and an avid collector of his work, but when she saw her finished portrait she confessed, 'the fat arms and heavy eyebrows bothered me.' In spite of the rapid brushwork and appearance of spontaneity, the portrait took a long time to make. Moll had to sit for 10 sessions, each of three hours. Every time Matisse altered one colour he felt forced to change another. The greenish blouse was at one time lavender white, and the black skirt yellowish green. The cotton print behind her – a studio prop which appears in several paintings of around 1908 – is painted over a green backdrop. But even when the sittings were over, Matisse remained dissatisfied. Then, inspired by a portrait of a woman by Veronese in the Louvre, he reworked the picture yet again, making the arms much fatter and emphasising the curve of the eyebrows. Although it took Moll time to get used to her new incarnation, the changes gave her figure the grandeur and monumentality that Matisse had been seeking.

▶ SEE RED MONSTER, MODERN ART

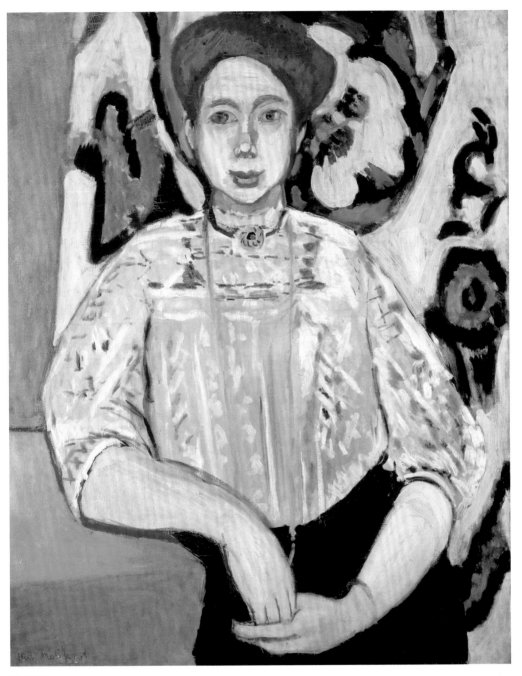

Eyebrows

F

Feathers and Fur …

Fabricated

Fabricated

DIRK BOUTS, THE ENTOMBMENT,
PROBABLY 1450S

Nearly all the paintings that have survived
from the fifteenth century and earlier
are painted on wooden panels, either
in tempera paint or in oils. But many
pictures of this time were painted on
fabric supports, most of which have
been destroyed. Some of these, such
as scenery and decorations made for
theatrical events, were intended to be
shortlived. But others have disappeared
because they were so fragile. Bouts's
Entombment is a rare survival. It is
painted onto a linen cloth with pigments
mixed in a glue medium. Because the
cloth has no ground (foundation layer)
the colours, which were applied very
thinly, have sunk into the fibres, leaving
a matt surface. Since the pigments are
bound with glue, the paint remains
water-soluble. One can only guess at
the numbers of pictures of this type

ruined by damp or exposure to water.
And pictures like this can never be
cleaned. The dirt of centuries has
accumulated in the fibres of the linen,
resulting in the muted colouring we
now see, but the dirt cannot be removed
without damaging the surviving paint.

So why should a painter like Bouts,
who normally painted with oils on
wooden supports, paint this extremely
fine religious work on linen? In the
nineteenth century this picture formed
part of an Italian collection, along
with other similar works that may have
formed a series of episodes from the life
of Christ. Three paintings similar in
size to the *Entombment* are known today,
which were probably part of the series.
If Bouts made the paintings for export to
Italy (as was commonly the case) it could
explain the choice of linen. Linen was
light and easy to transport. The pictures
would have been removed from their
stretchers and sent overseas rolled up.

Fake

The Italian painter Andrea Mantegna, who frequently painted on canvas, remarked that it 'can be wrapped around a rod'. Bouts's picture has a painted border that was probably intended as a guide for when the pictures reached their destination and were attached to a new stretcher or panel. The border indicates where the nails should go, ensuring that the canvas was restretched evenly, without distorting the image.

▶ SEE CONSERVATION, IN-LAWS, SOAKED

Fake

ITALIAN, PORTRAIT GROUP, EARLY
TWENTIETH CENTURY

In the basement of the National Gallery lurks a cracked and worm-eaten panel painting of a man and two children in Renaissance dress looking out of a window onto a view of Urbino and the Adriatic Sea. A coat of arms indicates that these are members of the Montefeltro family. When the picture was bought in 1923 it was thought to be by Melozzo da Forlì, an artist who worked at Urbino and was influenced by Piero della Francesca, Bramante, and various Netherlandish artists who were also employed at the court there. The profile format in particular recalls Piero's famous portraits of Federico da Montefeltro and his wife Battista Sforza, now in the Uffizi. But all is not as it seems. The little girl wears a cap that actually would have been worn only by boys, and the checked pattern of the man's hat was unknown in the 1490s – but was popular around 1913.

The painting is the work not of Melozzo but possibly of Icilio Federico Joni, a Sienese forger working in the early 1900s. Despite his erudite references to fifteenth-century painters, his knowledge of costume let him down and the painting has an immistakable whiff of art nouveau in its detail.

▶ SEE HAT TRICK, MISTAKEN IDENTITY, PALE IMITATION

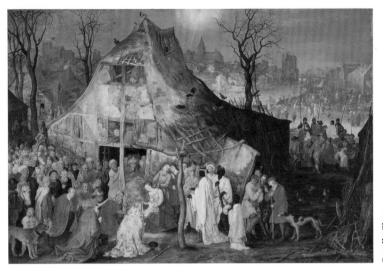

Family Firm

Family Firm

JAN BRUEGHEL THE ELDER, THE ADORATION
OF THE KINGS, 1598

The Brueghels certainly liked to keep
their art in the family. Jan Brueghel the
Elder, who painted this *Adoration of the
Kings*, was the son of the famous Pieter
Bruegel the Elder, brother to a painter,
Pieter Brueghel the Younger, and father
to another, Jan Brueghel the Younger.
His daughter, Anna, married the
Flemish painter David Teniers the
Younger. Even his grandmother,
Mayken Verhulst, was a painter. It was
she who took in Jan and his brother and
sister after their mother died and they
were orphaned. Mayken was said to be
one of the most important female artists
in the Low Countries and was known
for her miniatures and works in tempera
(paints made of pigment and glue or
egg) and watercolour. Jan and his
brother became her pupils, and it was
from her that he learned the technique

of painting bodycolour (a water-based
medium like gouache) on vellum, which
he used to wonderful effect in this small
and finely detailed painting. While he
was immensely accomplished in his own
right, Jan could not escape the shadow
of his father. He based the layout of the
principal elements of this painting on
an *Adoration* by Pieter Bruegel, now in
Brussels, while the poses of several of the
figures, including Balthazar the Moorish
King, Saint Joseph and the man talking
to him, are taken from his father's
painting of *The Adoration of the Kings*
in the National Gallery painted some
30 years before.

▶ SEE AERODYNAMIC, LIGHT OF THE WORLD,
VISION

Fashionably Late

J.A.D. INGRES, MADAME MOITESSIER, 1856

With the advent of digital photography
we can look at a picture as soon as we

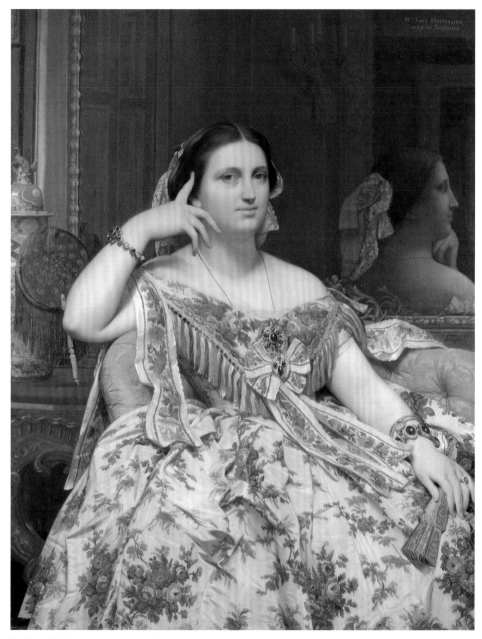

Fashionably Late

have taken it. What would we think if it took 12 years to get the results? That's how long Madame Moitessier had to wait for Ingres to finish her portrait.

Madame Moitessier was 23 when Ingres began painting her in 1844, and the mother of a baby girl. By 1847 it had been decided to include the four-year-old Catherine standing at her mother's knees, but the little girl fidgeted so much that the artist declared that the she was 'insupportable and that he was going to efface her', which he promptly did. The picture continued to make slow progress. Apparently it fell off the easel and was damaged. Then, in July 1849, Ingres's beloved wife died. Inconsolable and lonely, he lost all interest in his work and the portrait was abandoned. In 1851, pressure was put on Ingres to resume work. 'Our beautiful Madame, with all her goodness, could not abstain from reminding me that it is seven years since it was started,' Ingres complained. He responded by painting a new portrait of Madame Moitessier standing, but her husband insisted that the unfinished portrait should either be completed or destroyed. Ingres again resumed work, finally completing the painting in 1856 when, as the inscription on the frame of the mirror proclaims, the artist had reached the grand age of 76.

As time passed, fashions changed, and Ingres had to make changes as he worked on the picture if it was not to appear outmoded. At first Madame Moitessier wore a dark dress, then a yellow one, until finally Ingres chose to dress her in a splendid flowered creation, which fills the whole base of the picture, supported by the hoops of a newly fashionable crinoline. She has also adopted the 'barefaced-look', with her hair pulled back off her brow in a style made fashionable by the Empress Eugénie and considered outrageous on account of the provocative glimpses of ladies' ears it offered.

▶ SEE EYEBROWS, RELUCTANT SITTER

Favourite
CLAUDE, LANDSCAPE WITH HAGAR AND THE ANGEL, 1646

Sir George Beaumont is credited with being the chief force behind the founding of the National Gallery. When the Angerstein collection came up for sale in 1824, he challenged the government to act, saying, 'Buy Angerstein's pictures and I will give you mine.' The Angerstein collection of 38 pictures was bought for £57,000, together with the lease of Angerstein's house in Pall Mall, and in 1826 Beaumont handed over his pictures. But such was his fondness for this canvas, which he had owned for 40 years, that he soon regretted parting with it. 'He travelled with it, carried it about with him, and valued it beyond any picture he had,' recalled his friend Lord Monteagle. 'He dealt with it almost as a man might deal with a child he loved.' Unable to be without it, he asked to borrow it back, and it remained with him until his death, two years later, in 1828.

▶ SEE INCOGNITO, NUMBER 1, PALE IMITATION

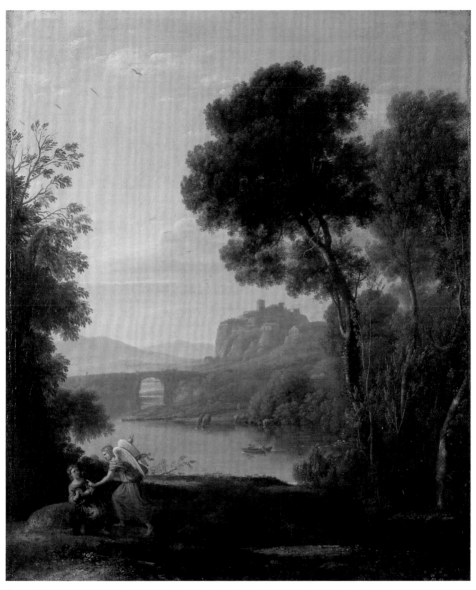

Favourite

In Claude's landscape … all is amenity and
repose; – the calm sunshine of the heart.

John Constable

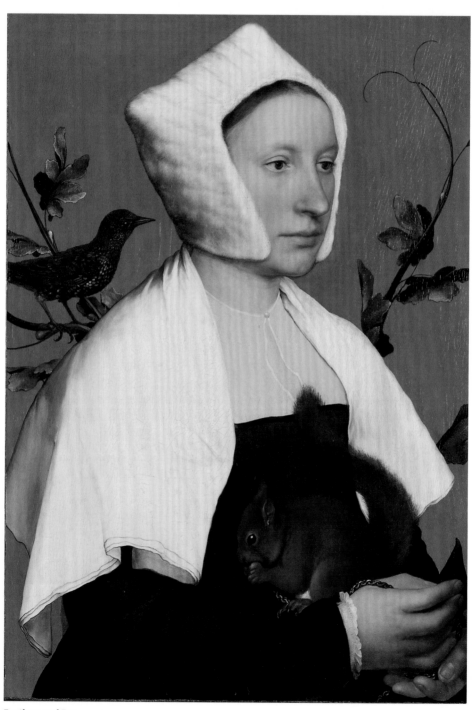

Feathers and Fur

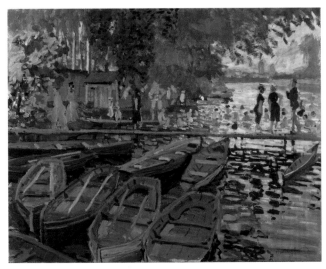

Feathers and Fur

HANS HOLBEIN THE YOUNGER, A LADY WITH
A SQUIRREL AND A STARLING (ANNE LOVELL?),
ABOUT 1526–8

So convincing is this depiction of
feathers and fur, we might well imagine
this lady posed for Holbein together
with the squirrel and the starling. But,
although squirrels were kept as pets, the
animals here are primarily emblematic.
Until recently no one had succeeded in
identifying the seated lady, although it
was presumed that she must have had
some connection with the court of
Henry VIII. But the squirrel and the
starling held further clues. They enabled
a connection to be made with Sir Francis
Lovell, an Esquire of the Body to Henry
VIII, who owned estates at East Harling
in Norfolk. Squirrels feature in his
family coat of arms and appear in stained
glass and on tombs in the parish church.
The presence of the starling is maybe

another allusion, punning on the name
of the village. The sitter is most likely to
be the wife of Sir Francis, Anne Ashby,
and the portrait may well have been
commissioned to celebrate the birth
of their son in spring 1526.

▶ SEE CODED MESSAGE, DEATH, HIDDEN MEANINGS

First Impressions

CLAUDE MONET, BATHERS AT LA GRENOUILLÈRE,
1869

During the summer of 1869 Monet
and Renoir worked side by side at La
Grenouillère, a popular bathing place on
the Seine, west of Paris. They produced
a series of pictures that have been hailed
as marking the birth of Impressionism.
With their crowds of fashionably dressed
people flaunting themselves in the
sunshine and the broken surface texture
of the painting, they are quintessentially
Impressionist in subject and treatment.
In a letter to his friend Jean-Frédéric

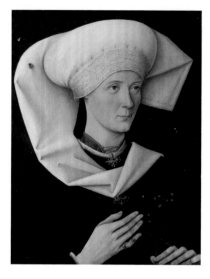

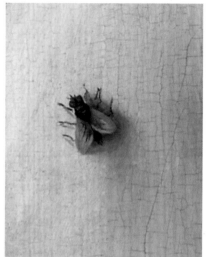

Bazille, written in September, Monet spoke of his plans for the next Salon exhibition: 'I have a dream, a painting of bathing at La Grenouillère, for which I did some bad sketches, but it's only a dream.' The two sketches by him that have survived (this one and one in the Metropolitan Museum of Art, New York) and which now seem so revolutionary, Monet saw merely as preparations for a more finished studio composition, and he may have submitted such a painting to the Salon in 1870 – which was then rejected by the jury. Certainly, in February 1873 he sold a painting of La Grenouillère to his dealer, Durand-Ruel, for 2,000 francs, a much larger sum than would have been paid at the time for a sketch. But, mysteriously, the picture has vanished. Could it be that Monet's last word on La Grenouillère is still lurking in someone's attic, waiting to be discovered?

▶ SEE EXILES, HOLIDAYS, MODERN ART

Fooling the Eye

SWABIAN, PORTRAIT OF A WOMAN OF THE HOFER FAMILY, ABOUT 1470

Our first impulse on looking at this painting is to swat the fly. What is it doing there on the surface of the painting? Or is it on the lady's cap? This is precisely the point. The artist has included the fly to trick us, to make us wonder if it is real or painted, and, when we discover it is painted, to marvel at his skill at imitating appearances. The fly is painted with extraordinary attention to detail and casts a little shadow on the woman's headdress.

During the Renaissance it became almost commonplace to include a creature such as a fly to fool the eye and draw attention to the artist's skill. There are paintings by Carlo Crivelli and Lorenzo Lotto in the National Gallery with flies in them too. In his book *Lives of the Artists*, Giorgio Vasari recounts that 'when Giotto was only

> A picture is something which requires as much knavery, trickery, and deceit as the perpetration of a crime.
>
> Edgar Degas

a boy with Cimabue, he once painted a fly on the nose of a face that Cimabue had drawn so naturally that the master returning to his work tried more than once to drive it away with his hand, thinking it was real.' This is a variation of the famous tale told by the Roman natural historian Pliny of a contest between two ancient Greek painters, Zeuxis and Parrhasius. Zeuxis made a painting of some grapes that was so realistic that the birds flew down to peck at them. And then he asked Parrhasius to pull back the curtain that he believed was covering his opponent's painting, only to find that he had been deceived and that the curtain *was* the painting.

▶ SEE ILLUSIONIST

Forgotten

PIETRO ORIOLI, THE NATIVITY WITH SAINTS, PROBABLY ABOUT 1485–95

Until recently, the altarpiece of *The*

Nativity and Saints by the Sienese painter Orioli was thought to be by Giacomo Pacchiarotto, another, slightly later, Sienese artist. In fact nearly everything Orioli painted was thought to be early work by the younger Pacchiarotto. How could Orioli, an artist who was highly regarded in his lifetime and described at the time of his death as 'a most excellent painter, and apt to become even better', just disappear from the history books? All too easily, thanks to the fact that his paintings are unsigned and he is recorded in few surviving documents. Added to that, Siena and its artists have always been overshadowed by the art of Florence. Orioli died in 1496 at the comparatively early age of 37, without having established a reputation beyond his native city. It was only due to the research of the Italian art historian Alessandro Angelini that Orioli's name was revived. In 1982 Angelini re-identified Orioli's work by comparing

Forgotten

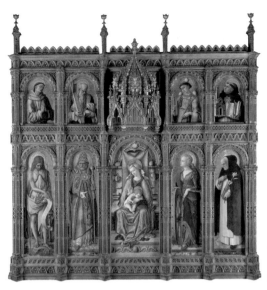

Framed

it with an important fresco in the Baptistery at Siena of *The Washing of the Feet* documented as being by him. Angelini's arguments convinced the art world and the labels on paintings changed all over the world to recognise the long forgotten Sienese master.

▶ SEE AERODYNAMIC, FAMILY FIRM, LIGHT OF THE WORLD

Framed

CARLO CRIVELLI, THE DEMIDOFF ALTARPIECE, 1476

One of the most imposing objects in the Sainsbury Wing of the National Gallery is The Demidoff Altarpiece. The altarpiece has two tiers of panels by Carlo Crivelli, contained within an elaborately carved 'gothick' frame complete with canopies and pinnacles. But the frame is not original. It was created for the great Russian collector

Prince Anatole Demidoff who bought these paintings in about 1854. When he owned the work, the construction was even taller, with another tier of pictures – which we now know came from a different altarpiece. Prince Anatole created a rich and fantastical arrangement to show off these gems of painting, but taste changes and by the 1970s the frame seemed excessive. It was removed and the paintings shown in narrow slip frames. But attitudes never stand still and by the time the Sainsbury Wing was opened in 1991, the frame had come to be valued in its own right as an important part of the history of the pictures. It was reinstated, but without the upper tier of panels, which had never belonged to the original altarpiece – a happy compromise perhaps between the historically accurate and the visually stunning.

▶ SEE MELODRAMA, ORB, SOAKED

G

Generations, Genuine Article, Geometry …

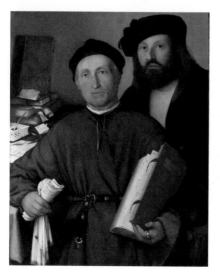

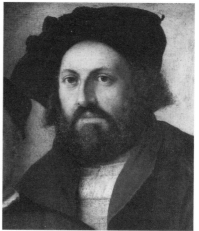

Generations

LORENZO LOTTO, GIOVANNI AGOSTINO DELLA
TORRE AND HIS SON, NICCOLÒ, ABOUT 1513–16

Niccolò della Torre was proud of
his father, Agostino, who was a
distinguished Bergamo physician,
and wanted to appear with him in
this painting. But they didn't sit for
the portrait together. As Lotto planned
the picture and – according to his
signature – completed it in 1515, it
showed Agostino alone surrounded
by the books and prescriptions, which
relate to his profession. Agostino died
a year later, in his early eighties, and
shortly after this Niccolò, who would
have been in his mid-thirties, got
Lotto to add his own likeness. There
was little alternative for the painter
but to squeeze him into the top corner,
in the narrow space between his
father's chair and the back wall,
where his presence is uncomfortable
and dominating.

By the beginning of the nineteenth
century, the appearance of Niccolò
must have begun to trouble viewers,
as there is evidence that he was altered
by restorers on two occasions. An
engraving of the painting of 1812 shows
the son with short hair and a high
forehead, wearing a broad-brimmed
hat and a coat of a different cut, changes
which had probably just been completed.
When it was next restored, in about
1860, the hat was changed for something
closer to the original, the hair made a
little longer and the coat again altered
(above). Only in 1965 during cleaning
at the National Gallery were these
'improvements' removed altogether
and Niccolò revealed as Lotto had
originally painted him.

▶ SEE CONSERVATION

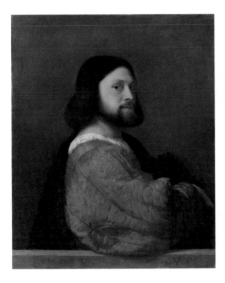
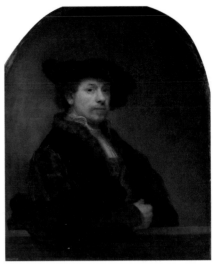

Genial Companions

TITIAN, A MAN WITH A QUILTED SLEEVE,
ABOUT 1510 (LEFT)
REMBRANDT, SELF PORTRAIT AT THE AGE
OF 34, 1640 (RIGHT)

Rembrandt was not noted for his
modesty and in this self portrait, made
when he was 34, he is really showing
off. With his arm resting confidently
on a stone ledge, dressed up in the rich
costume of a Renaissance gentleman,
he gazes out at us with supreme self-
assurance. There is no clue to his trade
as a painter. Instead, Rembrandt has
referred to two famous portraits by great
Italian masters of the previous century:
Raphael's likeness of the courtier,
diplomat and writer, Baldassare
Castiglione, now in the Louvre; and
Titian's, *A Man with a Quilted Sleeve*,
here in the National Gallery. While
the hat comes from Raphael, the pose
with the bent arm advancing towards
us is taken straight from the Titian.

Rembrandt had made a copy of the
Raphael when it came up for sale in
Amsterdam in 1639 and was bought
by an acquaintance of his, who, by
coincidence, also owned the Titian,
or a copy of it. At the time, the Titian
was thought to represent the celebrated
Italian poet Ariosto, and in mimicking
his pose, Rembrandt was inviting
comparison between himself and the
poet. Rembrandt was proclaiming to
the world that he was no mere artisan
painter, but an artist whose work could
rival the masterpieces of the great
artists and poets of the Renaissance.

▶ SEE MARTIAL ART, OFF-BALANCE, SUPERCILIOUS

To draw true beauty –
shows a master's hand.

John Dryden on Titian

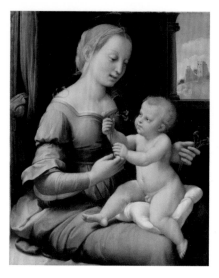

Genuine Article

RAPHAEL, THE MADONNA OF THE PINKS,
ABOUT 1506–7

When Nicholas Penny, the current Director of the National Gallery, spotted this lovely little painting in a corridor at Alnwick Castle, the ancestral home of the Dukes of Northumberland, it was actually the frame that set him on the path to a momentous discovery. Ever since the Raphael expert Passavant had cast doubts on its authenticity in 1835, the painting had been dismissed as a copy of a lost Raphael. When the Camuccini family sold it, along with the rest of their collection, to the Duke of Northumberland in 1854, they still maintained it was a Raphael, but the painting's reputation continued to be eroded by negative opinions and it later faded into obscurity. What struck Dr Penny was that the picture was in an elaborate old frame, suggesting that the painting had one time been regarded

as a genuine work by Raphael. He persuaded the Duke to allow him to take the picture to London to have it examined at the National Gallery. There was no question that the painting itself was of very high quality. But technical examination revealed that underneath the paint surface there is an exquisite underdrawing, freely drawn in silverpoint (above), which bears all the hallmarks of Raphael's hand. What is more, the underdrawing and the finished painting differ, particularly in the costume, which shows that the artist changed his mind as he worked on it. These changes rule out the possibility that the painting is a copy. No copyist wishing to pass the painting off as the original (one that was well known through prints) would have dreamed of making alterations to the costume. Even the pigments are typical of Raphael's palette and include some rare examples that ceased to be used by artists after the sixteenth century. And so

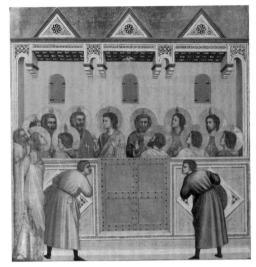

Geometry

a chance thought about a frame resulted in the rediscovery of a lost Raphael and its purchase by the gallery in 2004.

▶ SEE FRAMED

Geometry
ATTRIBUTED TO GIOTTO DI BONDONE,
PENTECOST, ABOUT 1306–12

Giotto's panel of the Pentecost shows that he was a master of geometry. The picture is constructed from a series of squares, rectangles, triangles and circles. The composition is symmetrical around a central axis, with even the two figures in the foreground mirroring each other's pose. While Giotto may well have resorted to rulers and compasses to plot his design, such was his skill that he was capable, according to the Renaissance biographer Giorgio Vasari, of drawing a perfect circle freehand. In his *Lives of the Artists*, Vasari tells the story of how a courtier was sent by the Pope to fetch a drawing from Giotto, and how, 'fixing his arm firmly against his side to make a compass of it, he made a circle so perfect it was a marvel to see it'. When the Pope saw the drawing, he realised 'that Giotto must surpass greatly all the other painters of his time'. The incident apparently gave rise to a proverb 'You are rounder than the O of Giotto' to describe a fool, since the word *'tondo'*, meaning round, signified in Tuscan 'not only a perfect circle but also slowness and heaviness of mind'.

▶ SEE POWER OF LOVE, PURLOINED, VISION

Graffiti
PIETER SAENREDAM, THE INTERIOR OF THE
BUURKERK AT UTRECHT, 1644

The Reformed Church in the Netherlands in the seventeenth century was strictly opposed to any frivolous decoration. The interiors of Dutch churches were whitewashed, the windows glazed with

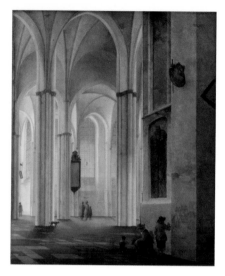

clear glass, and where Catholic churches were filled with paintings, here in Utrecht's Buurkerk, the only objects to break the monotony of the empty walls are, in the distance on one of the nave pillars, a guild board, on the right, the Tables of the Ten Commandments, and above, some heraldic devices. But out of sight of any officious clerics, two boys are getting up to mischief. While one plays with his dog, the other covers the wall with graffiti. He seems to have made a crude drawing of a horse with four riders on it, but there is just enough detail for the subject to be identifiable. It represents the four sons of Duke Aymon, heroes of a popular French medieval tale who fought against the Emperor Charlemagne, on their enchanted steed Bayard. Their horse had the magical ability to lengthen its body so that all four brothers could ride on it together. What is the significance of this graffiti? It may be no more than an amusing piece of observation to give the picture greater truth to life. But the fact that Saenredam himself has signed and dated the painting in an inscription underneath the drawing, as though he was giving his name to the graffiti as well as the picture, seems to add to its significance.

▶ SEE ABSENCE

Great Escape

PAOLO UCCELLO, SAINT GEORGE AND THE DRAGON, ABOUT 1470

Adolf Hitler seized Uccello's *Saint George and the Dragon* at the beginning of the Second World War and gave orders that it should be destroyed rather than fall into the hands of the Allies. The painting was one of the treasures of the Lanckoroński collection in Vienna, housed in the family's magnificent palace there. When Austria was annexed by Germany in 1938, Nazi officials took

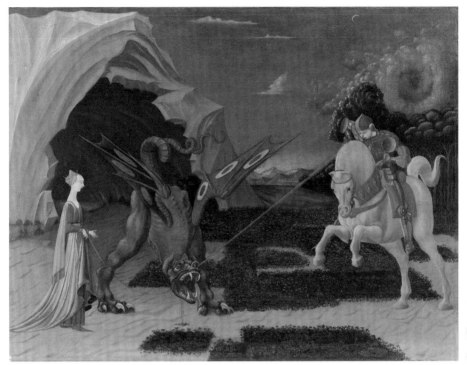

Great Escape

the opportunity to seize works of art not only from Jewish collectors but also from other families of non-Austrian origin, including the Lanckoroński. Hermann Göring took two paintings for himself but Hitler ordered him to return them and decreed that all confiscated works should remain in Austria. But when war broke, Hitler himself seized most of the Lanckoroński collection for an intended Hitler Museum in Linz. Many of the works of art were taken to Schloss Hohenems in Vorarlberg where they were destroyed by a fire – a fate that befell the Lanckoroński palace in Vienna too in 1945. By luck, the Uccello happened to be stored elsewhere, probably in a salt mine in Altaussee. As the war came to a close, an Austrian officer who refused to obey the order to destroy the looted art saved the Uccello from destruction. At the end of the war, the painting was recovered by American troops and sent to the Collecting Point in Munich, where confiscated works of art were assembled for return to their rightful owners. It was claimed by Count Lanckoroński who, fearful for its safety, consigned it to a bank vault in Zurich, where for years it remained hidden from view, until it was sold to the National Gallery in 1959.

▶ SEE BOMBPROOF, PURLOINED

H

Hat Trick, Hero Worship, Holidays ...

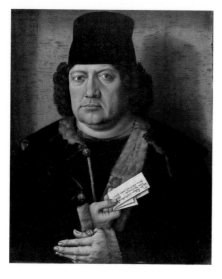 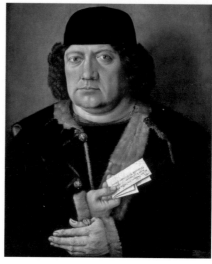

Hat Trick

Hat Trick

MASTER OF THE MORNAUER PORTRAIT, PORTRAIT
OF ALEXANDER MORNAUER, ABOUT 1464–88

When this fifteenth-century portrait
of Alexander Mornauer, a town clerk
from Landshut in Bavaria, entered the
gallery in 1991 it looked very different.
The background was intense blue and
the sitter was wearing a round skullcap
(right). Scientific analysis revealed,
however, that the background was painted
in Prussian blue – a pigment not used
before the eighteenth century – and that
it could not be original. It was also
discovered that the hat had been altered.
It was decided to remove the later
additions to reveal what the painter had
originally intended. Underneath lay a
well-preserved background painted to
resemble wood grain with darker shadows
adding a sense of depth, while the hat
turned out to be tall and square (left).

How and why had the changes been
made? In the eighteenth century the
picture was thought to be a portrait of
the Protestant reformer Martin Luther
by Hans Holbein. Holbein commonly
used a bright blue background in his
portraits and it is probable that a canny
dealer had the painting altered to make
it more appealing to collectors.

▶ SEE FAKE, MISTAKEN IDENTITY, PALE IMITATION

Hero Worship

PETER PAUL RUBENS, PORTRAIT OF SUSANNA
LUNDEN (?) ('LE CHAPEAU DE PAILLE'), PROBABLY
1622–5 (LEFT) AND **ELIZABETH LOUISE VIGÉE
LE BRUN,** SELF PORTRAIT IN A STRAW HAT,
AFTER 1782 (RIGHT)

Two portraits of women beckon across
the rooms of the National Gallery, like
they are sisters or best friends. Rubens's
Portrait of Susanna Lunden, with her
alluring glance, her décolletage, and her
wide-brimmed feathered hat, pictured
against a summer sky, is the model and
inspiration for Vigée Le Brun's self
portrait (an autograph replica of a

picture of 1782). The French artist has also depicted herself against a cloud-flecked sky – her palette and brushes in her hand – wearing a revealing low-cut gown and a straw hat decked with flowers. She had seen Rubens's painting in a private collection in Antwerp in 1782, while on a tour of the Low Countries with her husband, and immediately resolved to paint her own portrait in homage to it. As she later wrote, she wanted to capture the same effects of bright sunshine and luminous shadow. Her hat is a playful reference to the nickname that Rubens's painting had by then acquired: 'Le Chapeau de Paille' (the straw hat). In fact, in Rubens's portrait, Susanna Lunden – the sister of Helen Fourment, who was to become Rubens's second wife in 1630 – does not wear a straw hat but one of beaver felt. Vigée Le Brun's self portrait was exhibited to great acclaim at the Paris Salon of 1783, she was elected to the

Académie Royale, and in recognition of her allegiance to the Flemish painter she was dubbed 'Madame Rubens'.

▶ SEE ANATOMY, DIPLOMACY, JIGSAW

Hidden Meanings

GERRIT DOU, A POULTERER'S SHOP, ABOUT 1670

At first glance, Dou's painting seems to be no more than a charming picture of everyday life, rendered in amazing detail with consummate skill. But it's not as innocent an image as it appears. The Dutch loved hidden meanings and their paintings are often packed with them. It helps here to know that words connected with birds were rich in sexual allusion: *vogelen* (to bird) was used for sexual intercourse, *vogel* (bird) could mean phallus, and a bird-catcher could refer to a procurer. An empty cage, like the one that hangs above the girl, and a broken pot, like the one the hen at the bottom drinks from, were common symbols

Hidden Meanings

Colour is my day-long obsession, joy and torment.

Claude Monet

of lost chastity, and the hare, like the rabbit, was emblematic of lust. So the girl who reaches eagerly towards the hare may be likened to the caged hen reaching out to quench its thirst. The message is reinforced in the antique-style relief sculpture on the wall where classical putti play with a goat, the embodiment of sexual lust. It explains the older woman's disapproval of the girl's choice. She holds the hare at arm's length, as if to say 'you're not ready for this yet'.

▶ SEE CODED MESSAGE, FEATHERS AND FUR

Holidays
CLAUDE MONET, THE BEACH AT TROUVILLE, 1870

Monet spent the summer of 1870 with his wife Camille on the Channel coast, where they were joined by the older painter Eugène Boudin. The woman on the left in this painting is Camille, and the one on the right is probably Madame Boudin.

This painting was made on the spot and, to prove it, the surface is peppered with specks of sand blown there by the very wind that Monet depicts chasing the clouds across the sky. The sand shows up like a fine snow across the blacks of Madame Boudin's costume and in denser patches at the bottom. Sand is mixed up in the paint too, where it must have blown on to the artist's palette. It can't have been easy painting in a stiff breeze and Monet worked fast and furiously, laying the highlights on in thick slabs and not bothering to cover the whole surface of the canvas. But he must have been pleased with the effect as he initialled and dated it: Cl. M. 70.

Boudin, too, must have had fond memories of that holiday because almost 30 years later he wrote to Monet, 'I have even preserved from that time a drawing that represents you on the beach . . . Little Jean plays on the sand and his papa is seated on the ground, a sketchbook in his hand.'

▶ SEE EXILES, FIRST IMPRESSIONS, MODERN ART

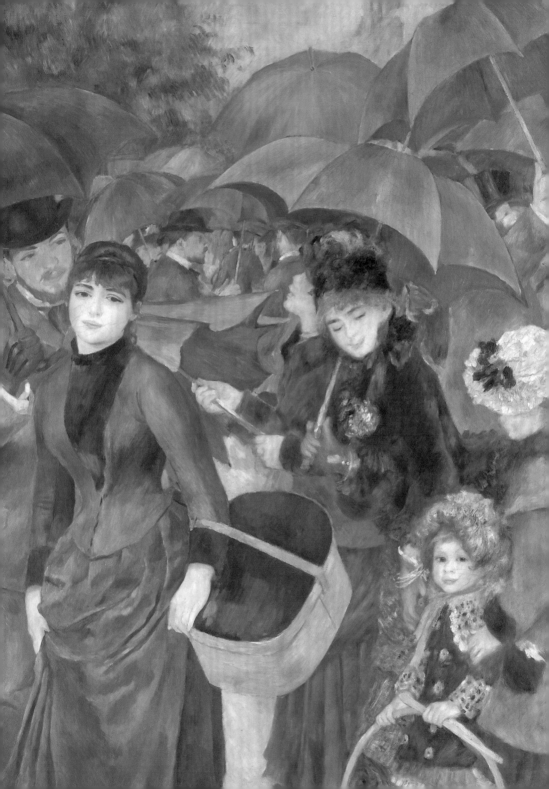

I

Illusionist, Incognito, In-Laws…

Identity Crisis

About 1883, I had rung Impressionism dry

Renoir

Identity Crisis

PIERRE-AUGUSTE RENOIR, THE UMBRELLAS, ABOUT 1881–6

In 1881 Renoir began this painting, went on holiday, and rejected Impressionism.

This painting looks like the work of two different artists. The figures on the right are painted in a loose, Impressionist style with feathery brushwork, blurred contours and intense blues. The rest of the picture is more linear and more sombre in colouring. But despite appearances, *The Umbrellas* is all the work of Renoir. He started it in about 1881, painting the figures on the right, but then put it aside and only finished it about five years later. The differences in the fashions of the clothes confirm a gap of several years.

During those years Renoir rethought his whole approach to painting. He visited Italy, where he was impressed by Raphael's frescos in the Vatican and the ancient Roman wall paintings in Naples, and he stayed in the South of France with Cézanne, absorbing his techniques. From Aix-en-Provence he wrote, 'I am in the process of learning a lot. While warming myself and observing a great deal, I believe I shall have acquired the simplicity and grandeur of the ancient painters.' When Renoir revisited *The Umbrellas*, his style had undergone a radical change. The girl on the left, with her perfect oval face, is a homage to Raphael. Her dress and the umbrellas are simply modelled, and, in place of his earlier brushwork, Renoir uses parallel strokes of colour, just like Cézanne. What is curious is that he didn't repaint the figures on the right, with their outmoded fashions. Although he chose to no longer paint like an Impressionist, Renoir must have been too pleased with what he had done to change them just for the sake of consistency.

▶ SEE GENUINE ARTICLE, MODERN ART, STRIPTEASE

Illusionist

Illusionist

JAN VAN EYCK, PORTRAIT OF A MAN
(SELF PORTRAIT?), 1433

The survival of an original frame on a painting from the fifteenth century is unusual enough, but one that bears the signature of the painter is rare indeed. The gilded frame on van Eyck's *Portrait of a Man* bears an inscription along its bottom edge that reads 'JAN VAN EYCK ME FECIT ANO M.CCCC.33. 21.OCTOBRIS' – Jan van Eyck' made me on 21 October 1433.

As if the portrait were not remarkable enough in its intense scrutiny of a particular individual (thought to be the artist himself), the inscription is a tour de force of illusionism. It is painted to look as if it has been etched, and is touched with minute highlights in the fictitious grooves, to add to the appearance of depth. By pretending that the portrait was made on a single day, the inscription reinforces the sense that

the life of the man has been miraculously arrested.

At the top of the frame is another painted inscription, in a Greek-type script, which interpreted reads as ALS ICH CAN, or, in English, *As I can*. It refers to an old Flemish saying: 'As I can, not as I would.' The word *ich* is a pun on the artist's name *Eyck* and van Eyck seems to have adopted the phrase as his personal motto – it appears on his portrait of his wife, and on a small devotional panel which belonged to him. As he seems to have reserved the use of the motto for pictures of personal significance, its presence here adds weight to the suggestions that the man in the turban is van Eyck himself.

▶ SEE ENIGMA, FOOLING THE EYE, GENIAL COMPANIONS

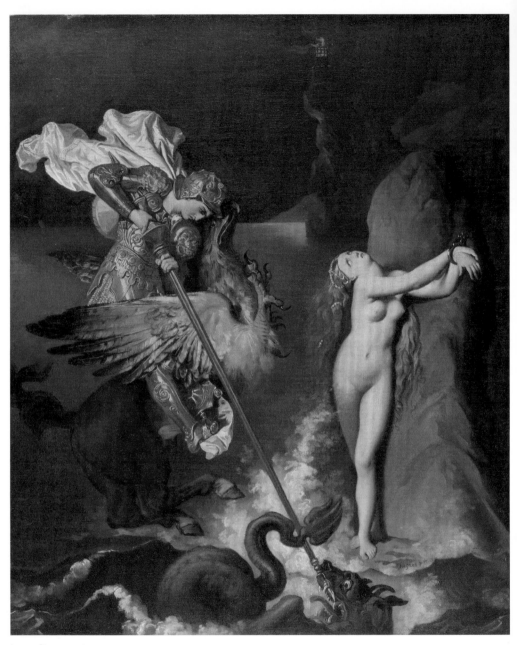

Incognito

Incognito

M. Ingres is a wonderfully
clumsy draughtsman
who knows nothing of
aerial perspective and …
his painting is as flat as
a Chinese mosaic.

Charles Baudelaire

Incognito

J. A. D. INGRES (1780–1867), ANGELICA
SAVED BY RUGGIERO, 1819–39 (LEFT)
EUGÈNE DELACROIX, PORTRAIT OF BARON
SCHWITER (ABOVE)

Sir Charles Holmes, Director of the
National Gallery, shaved off his
moustache and donned spectacles to
avoid being recognised when he went
to the sale of the collection of the late
painter Edgar Degas in Paris, in March
1918. He succeeded in buying Manet's
Execution of Maximilian, Delacroix's
Portrait of Baron Schwiter, four paintings
by Ingres including *Angelica saved by
Ruggiero*, and a flower piece by Gauguin.

The circumstances of the sale
were extraordinary. Paris was under
bombardment by German long-range
guns, the 'Big Berthas', and there was
a real fear that France might fall. The
National Gallery's purchase grant had
been suspended on account of the war,
but the painters Duncan Grant and

Vanessa Bell urged their friend, the
economist Maynard Keynes, who was
working in the Treasury, to use his
influence. Keynes persuaded Lord Curzon,
a member of the Cabinet and a Gallery
Trustee, that this was a chance not to be
missed and a special grant of £20,000 was
made. Curzon arranged for Holmes to
travel to Paris with an International
Financial Mission of which Keynes was
part. Holmes later recalled the hazardous
journey by sea 'with escorting destroyers
and a silver airship watching overhead',
then by rail across war-torn France with
its endless queues of refugees, and the
excitement of the sale itself. On his return
to England, Keynes wrote to his mother
with news of their success: 'The Inter
Ally Council itself was largely a farce.
But there was the contrasted interest of
my picture sale and of proximity to this
great battle. I bought myself four pictures
and the nation upward of twenty.'

▶ SEE CENSORSHIP, GREAT ESCAPE

In-Laws

ANDREA MANTEGNA, THE AGONY IN THE
GARDEN, ABOUT 1460 (TOP)
GIOVANNI BELLINI, THE AGONY IN THE GARDEN,
ABOUT 1465 (BOTTOM)

Two paintings of the same subject, painted within 10 years of each other, hang together in the National Gallery. They show the *Agony in the Garden* and are remarkably similar. In both, Christ kneels in prayer on a rocky mound while three disciples sleep (one of them drawn in extreme foreshortening, his legs stretched towards us). Around them spreads a broad landscape lit by the dawn sky and in the distance approaches a procession of soldiers, led by Judas.

It's no wonder that the pictures are so alike since the artists who painted them were brothers-in-law. The younger of the two, Bellini, must have regarded his sister's husband, the precocious Mantegna, with something approaching awe.

A deliberate act of artistic sabotage led to the marriage. Mantegna was the foster-child and protégé of Francesco Squarcione, the leading painter in Padua and chief rival of Giovanni's father, Jacopo Bellini, the head of the most powerful artistic dynasty in Venice. Mantegna had already attracted attention in Padua, and perhaps, sensing that he was unhappy at his exploitation by Squarcione (who even put his own signature to his pupil's work), Jacopo arranged Mantegna's marriage to his daughter, Niccolosia. If Jacopo thought that he had secured the most gifted young painter in Italy, he failed to reckon with the scale of Mantegna's ambition. The young artist used his wife's dowry to free himself of any legal obligation to Squarcione and, in 1459, got himself appointed painter to the Gonzaga court at Mantua, and then worked for the Pope in Rome.

▶ SEE ANTIQUITY, FABRICATED, NUMBER 1

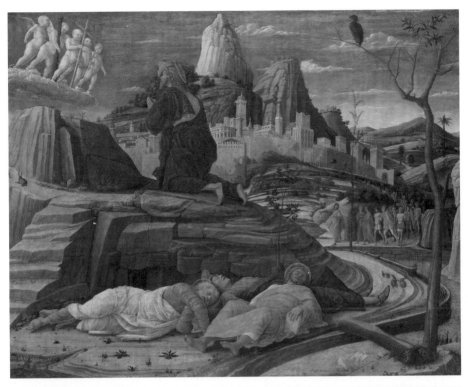

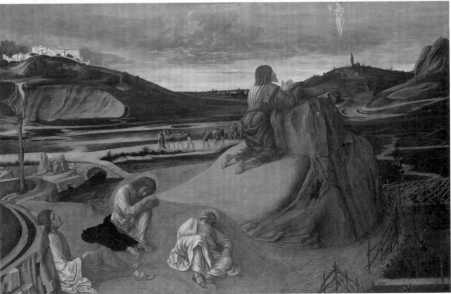

In-Laws

J, K & L

Jigsaw, Kingdom Come,
Lowering the Tone …

Jigsaw

Kingdom Come, detail

Jigsaw

PETER PAUL RUBENS, 'THE WATERING PLACE',
1615–22 (TOP, LEFT) AND A SHEPHERD WITH
HIS FLOCK IN A WOODY LANDSCAPE, PROBABLY
1615–22

If you look at Rubens's '*The Watering Place*' in a certain light you can see the edges of the pieces of wood. In fact it's made up of no less than eleven pieces of wood, running both horizontally and vertically, all glued together. This makes '*The Watering Place*' one of the most vulnerable pictures in the National Gallery Collection because any change in humidity could make the wood expand or contract in different directions, causing the panel to split. Why should Rubens choose to work on such a patchwork of pieces? The answer lies in another painting by him in the collection, *A Shepherd with his Flock in a Woody Landscape*. Comparing the two paintings, you can see that the left-hand side of '*The Watering Place*' is a slightly

altered and reduced version of the other picture. The figures are different, but the placing of the trees and the overall composition are virtually identical. Rubens then had the panel enlarged, perhaps in more than one stage, with the addition of more strips of wood, to create a new, larger painting. This is not the only time he worked in this way. Instead of working out his design in advance, Rubens often liked to alter and improvise as he went along.

▶ SEE DIPLOMACY, HERO WORSHIP, MELODRAMA

Kingdom Come

BARTOLOMÉ BERMEJO, SAINT MICHAEL
TRIUMPHS OVER THE DEVIL, 1468

Bermejo's Saint Michael glistens and gleams with reflections, as if he were designed to advertise the painter's brilliant mastery of oil painting. He wears a suit of gleaming golden armour inlaid with precious gems; his headpiece

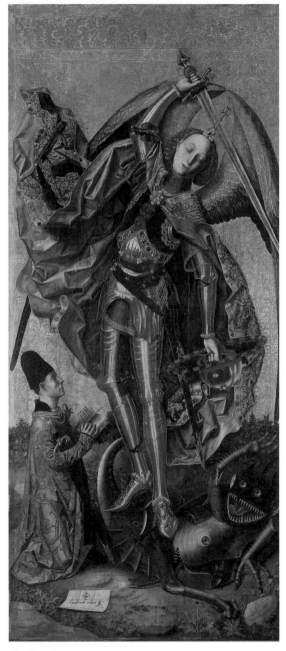

The demon on whom Michael treads ... is a fantastic chimera ... Would donor and artist have been horrified to know how irresistible he looks to me, a twenty-first century viewer weaned on comics and cartoons – or was ridicule part of Bermejo's strategy?

Erika Langmuir, art historian

Kingdom Come

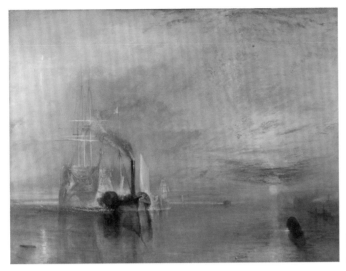

Last Voyage

is a cluster of pearls, topped with a golden cross; his brocaded cloak is lined with silky red cloth and edged with pearls and rubies; and he carries a crystal-domed globe which reflects and refracts the light. And, as if to complement the archangel Michael, the cowering devil is shiny and metallic too.

The vanquishing of the devil takes place in a rocky landscape in which kneels a praying donor, the Spanish knight Antonio Juan. Saint Michael is God's lieutenant at the Last Judgement, and his armour gives a glimpse of another, more glorious place. Reflected in miniature on his polished breastplate is a vision of the Heavenly Jerusalem, with a panorama of spires and steeples, which Antonio Juan lives in the hope of seeing for himself.

▶ SEE ENIGMA, ORB

Last Voyage
J.M.W. TURNER, THE FIGHTING TEMERAIRE, 1839

When Turner exhibited this painting (his 'Darling' as he called it) at the Royal Academy in 1839, he gave it the title: *The Fighting Temeraire, tugged to her last berth to be broken up, 1839.* While the picture is a magnificent elegy to a great warship that had distinguished itself at the Battle of Trafalgar alongside Nelson's *Victory*, the title is a terse record of the event that had inspired Turner to paint the picture. It suggests that Turner has depicted the towing of the *Temeraire* on its final voyage as it actually happened. In his biography of Turner published in 1862, Walter Thornbury claimed that Turner saw the *Temeraire* on the river with a party of brother artists, among them the marine painter Clarkson Stanfield. 'Suddenly there moved down upon the artists' boat the grand old vessel that had been taken prisoner at the Nile, and that led the van at

Last Voyage

The sun is God

Turner's last words

Trafalgar. She loomed through the evening haze pale and ghostly, and was being towed to her last moorings at Deptford by a little, fiery, puny steam-tug. "There's a fine subject, Turner," said Stanfield. So Turner painted it.' Another account, published in 1910, claimed that Turner was on a steamboat when 'in the midst of a great blazing sunset, he saw the old *Temeraire* drawn along by a steam tug'.

The haze must have been very dense for Turner to imagine he saw the *Temeraire* as he painted her. In fact the ship had already been stripped of its masts, its riggings and its guns before it was towed from Sheerness to Rotherhithe to be broken up, and was no more than a great unwieldy hulk. The tow took place over two days in September 1838, almost certainly during daylight hours, and the ship was pulled by two steam tugs not one. The great expanse of water in Turner's painting

suggests that the setting is the Thames estuary, early in the course of the tow. As the journey was westward up the river, it would have been impossible for the vessels to have the sunset behind them as Turner has shown. There is no proof that Turner witnessed the towing of the *Temeraire* at all, and he may in fact have been away on one of his Continental painting trips at the time.

All of which goes to show that biographers are not always to be believed and that painters are entitled to use artistic licence when creating works of art. The novelist William Thackeray compared the picture to 'a magnificent national ode or piece of music'. If Turner had painted only the bare facts, the result would hardly have been so poetic.

▶ SEE FAVOURITE, RACE

Light of the World

> In art there is no need for colour; I see only light and shade. Give me a crayon, and I will *paint* your portrait.
>
> Francisco Goya

Light of the World

GEERTGEN TOT SINT JANS, THE NATIVITY AT NIGHT, POSSIBLY ABOUT 1490

The image of the radiant Christ Child in the crib, illuminating the stable is so familiar that we take it for granted. Rembrandt famously showed the holy family and shepherds bent over the glowing manger. Saint John's Gospel speaks of Christ as 'the Light of the World', but how and when did artists come to show the Christ Child as a source of light? This oil painting made in the Netherlands towards the end of the fifteenth century is one of the first to set the Nativity in darkest night, with the chief source of light coming from the baby. In the background are two more light sources – the shepherds' campfire and the divine light emanating from the angel who announces the birth of Christ. There could have been a fourth source – a candle held by Saint Joseph on the right – but this may have been lost when the picture was trimmed down at some point in the past. However, these lights are insignificant compared to the light coming from the child.

The artist of this picture is indebted to Saint Bridget, a fourteenth-century Swedish mystic, who described a vision she had in which she saw Mary give birth as if light passed through her body. Joseph had brought a candle, but the newborn child was bathed in a divine light that overwhelmed the earthly light of the candle. 'I saw the glorious Infant lying on the ground naked and shining . . . Then I heard also the singing of the angels, which was of miraculous sweetness and great beauty . . . When therefore the Virgin felt that she had already born her Child, she immediately worshipped him, her head bent down and her hands clasped, with great honour and reverence, and said to him: Be welcome my God, my Lord, and my Son.'

▶ SEE AERODYNAMIC, FORGOTTEN, VISION

Michelangelo . . .
could not make a
mark which was
devoid of grandeur.

Kenneth Clark

Lost and Found

Lost and Found

MICHELANGELO, THE ENTOMBMENT, 1500–1

Michelangelo considered himself a
sculptor, and in fact could be quite a
reluctant painter. This is why his panel
paintings are rare and are sometimes
incomplete. A fresco painting, where
the paint is brushed directly onto wet
plaster, like the ceiling of the Sistine
chapel, is not easily moved. A panel
painting, particularly one that was
never finished, is far more vulnerable.
It is probable that *The Entombment* is
the altarpiece that Michelangelo was
commissioned to paint for the church
of San Agostino in Rome in 1500. But
it was never delivered and Michelangelo
returned his fee. What happened to
the altarpiece after that is unclear. It is
recorded in the Farnese Collection in
1647, and in the nineteenth century was
part of a vast collection accumulated by
Napoleon's uncle, Cardinal Fesch. But
when Fesch's collection was sold, the

picture must have been so obscured
by dirt and varnish that it went
unnoticed. In 1848, a Scottish painter,
Robert Macpherson, discovered it in
Rome, serving, according to different
accounts, as the roof of a fish stall or
as part of a pedlar's cart. He rescued
it, established its identity, and 20 years
later sold it to the National Gallery
for the lordly sum of £2,000.

▶ SEE FABRICATED, NUMBER 1

Lowering the Tone

EDOUARD MANET, MUSIC IN THE TUILERIES
GARDENS, 1862 (LEFT)
ADOLPH MENZEL, AFTERNOON IN THE TUILERIES
GARDENS, 1867 (RIGHT)

Imitation, they say, is the sincerest form
of flattery, and when Menzel made a
painting of the crowds in the Tuileries
Gardens in Paris it was as a kind of
tribute to Manet, who had painted his
own view of the gardens five years

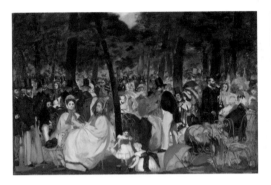

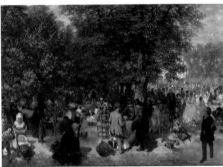

earlier. Menzel, the leading German painter of his day, was visiting Paris for the Universal Exhibition and would have seen Manet's painting at a show near the exhibition grounds.

Their paintings have much in common. Both show the bustling crowds promenading and relaxing on a summer's day. Nursemaids attend to their charges, young children play in the sand with their spades, a variety of dogs pursue their canine interests, top-hatted gentleman pay court to fashionably dressed ladies with parasols. But while it is recognisably the same place and in many respects the same world, it is as though the artists have viewed it through different lenses. Manet has eyes only for the fashionable. Among his promenaders are the cultural élite of Paris – the writers Théophile Gautier and Charles Baudelaire, the composer Jacques Offenbach, and Manet himself – and the ladies to whom

they pay court are demure and elegant. Even the children are perfectly behaved. Menzel's crowd is altogether more raucous. The children scream, the nursemaids reprimand, and an elderly couple bicker. Menzel records every incident with a realist's eye for detail. Manet, by contrast, leaves faces and details blurred, and lingers with a painter's fascination on the curlicues of a wrought-iron chair or the facets of an umbrella. He delights in the colours of summer clothes, the blond dresses of the women and the bright splashes of their ribbons set against the greys and blacks of the men's pantaloons and top hats. There is no place for vulgar incident. Indeed the only part of Menzel's painting that bears a stylistic resemblance to Manet's is the distant crowd on the right, where detailed realism gives way to Impressionism, and all we see is a patchwork of colours.

▶ SEE CENSORSHIP, HERO WORSHIP, HOLIDAYS

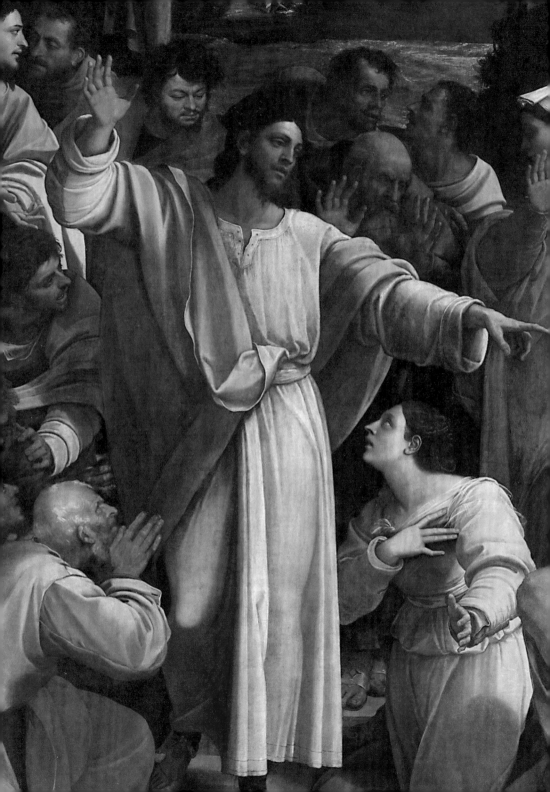

M&N

Melodrama, Mystery, Number 1 …

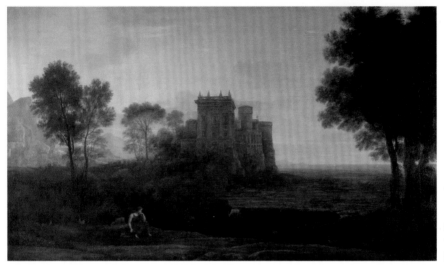

Magic Casements

CLAUDE, 'THE ENCHANTED CASTLE', 1664

In March 1818, the poet John Keats wrote a verse letter to his friend John Hamilton Reynolds in which he gave a long 'gothic' description of a castle: 'You know the Enchanted Castle it doth stand / Upon a Rock on the Border of a Lake / Nested in Trees, which all do seem to shake / From some old Magic like Urganda's sword . . .' The picture that prompted his fanciful account was a well-known engraving called 'The Enchanted Castle', after Claude's painting *Pysche outside the Palace of Cupid*. Keats cannot have seen the painting at that time but Claude was a favourite among the English Romantic poets who shared the painter's passion for ideal pastoral beauty. Just over a year later, in the summer of 1819, when he was working on his 'Ode to a Nightingale', Keats did have an opportunity to see the painting because it was on show in an exhibition at the British Institution in London, only a few miles from Hampstead, where he was living. Considering his interest in painting and his friendship with artists and critics, it seems highly likely that Keats would not have missed such an opportunity. If he did see it, might this picture, with its unforgettable image of a palace with tall windows and castellated towers perched on a rocky promontory overlooking the sea, have inspired the lines from 'Ode to a Nightingale' evoking 'Charm'd magic casements, opening on the foam / Of perilous seas, in faerie lands forlorn'?

▶ SEE FAVOURITE

Martial Art

CAREL FABRITIUS, YOUNG MAN IN A FUR CAP, 1654

Why should this Dutch painter show himself wearing a metal breastplate?

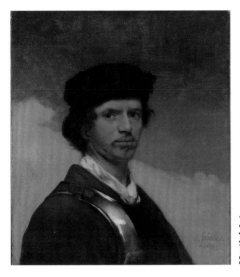

Martial Art

Fabritius was no soldier, but neither was his teacher, Rembrandt, who also depicted himself in armour. Perhaps there is an element of dressing up involved (Rembrandt often painted himself in the studio costumes he kept for his paintings of historical and biblical subjects). Or the armour could have had patriotic associations, indicating that the wearer was ready to fight in defence of his country.

Or the clue may lie in the artist's prominent signature – C. Fabritius – at the bottom right of the canvas. The surname 'Fabritius' comes from the Latin word *faber*, meaning a workman or artisan, and was used at the time by builders, carpenters and other manual workers. Fabritius had been a carpenter before turning to painting. But the name also had more heroic associations. The Roman historian Plutarch tells of a soldier named Caius Fabricius who was distinguished for his honesty and

austerity. By dressing himself in military armour, the young painter is perhaps claiming a more illustrious pedigree than his humble origins would warrant.

▸ SEE DISTORTION, GENIAL COMPANIONS, THUNDERCLAP

Melodrama

FRANCESCO PESELLINO, COMPLETED BY FRA FILIPPO LIPPI AND WORKSHOP, THE PISTOIA SANTA TRINITÀ ALTARPIECE, BETWEEN 1455 AND 1460

The story of Pesellino's Trinity altarpiece has all the elements of melodrama: the death of the artist before it was completed, a financial dispute between his widow and his business partner over payment, the completion of the painting by another artist, Fra Filippo Lippi, the savage dismemberment of the altarpiece in the eighteenth century, and the eventual reuniting of the scattered fragments – culminating, after many years, with a happy ending.

Melodrama

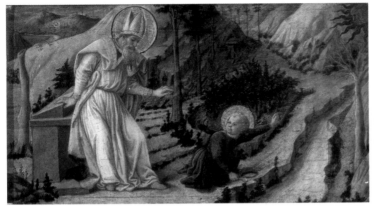

That a painting as fine as this came to be deliberately cut up is hard to believe. But it appears that when the Confraternity in Pistoia, for which it was painted, was suppressed in about 1783, the altarpiece was sawn up and sold off in bits – presumably to maximise profit. The main altarpiece was cut into five pieces – the central Crucifixion with the Trinity, the angels at top left and right, and the two pairs of saints at left and right – and separated from the *predella* (a long panel with scenes painted on it, that runs along the bottom of an altarpiece). When the gallery bought the Crucifixion fragment in 1863, a search began for the rest. The two angels were recovered in 1917, and in 1919 King George V allowed the fragment of the two saints on the left, by then in the Royal Collection, to be on permanent loan so that it could be shown with the other pieces. In 1929, the right-hand pair of saints was found, but cut down at the bottom. The missing section showing the robes and feet of the saints was made up by a restorer and to this day is clearly presented as an addition. Four small scenes, part of the original *predella*, were found in Pistoia some time in the later nineteenth century and bequeathed to the gallery in 1937. However, experts long believed that there was definitely a fifth scene missing from the predella. The final part of the jigsaw remained undiscovered until 1995, when a small painting showing the *Vision of Saint Augustine* in The State Hermitage Museum, St Petersburg (above), was identified as being the missing piece. This part is now the only element of the altarpiece that remains separated from the rest.

▶ SEE REUNITED, SOAKED

Mistaken Identity

Mistaken Identity

ANDREA PREVITALI, SCENES FROM TEBALDEO'S ECLOGUES, PERHAPS ABOUT 1505

As Director of the National Gallery, Kenneth Clark prided himself on his purchases, but in 1937 he made a grave mistake which threatened his position. He fell in love with four little Italian paintings showing figures in Arcadian settings, which he thought might be by Giorgione. They were shown to the Gallery Trustees, who shared his enthusiasm, and the National Art Collections Fund agreed to buy them for the Gallery. A condition of the gift was that they should be labelled as being by Giorgione. Clark had made it clear that they were not necessarily the work of Giorgione, but he agreed to the condition. When the purchase was announced, it was greeted with a storm of criticism, both of Clark and the pictures, which rumbled on in the press for months. The situation was made even worse by the discovery that the paintings were in fact early works by a less important painter, Previtali, five of whose pictures were already in the Collection. The offending works were relegated to the obscurity of the basement galleries but Clark managed to hold on to his job. He would go on to successfully and safely guide the National Gallery through the eventful years of the Second World War.

▶ SEE FAVOURITE, INCOGNITO

Modern Art

PIERRE-AUGUSTE RENOIR, THE SKIFF, 1875

Renoir's *The Skiff* has all the hallmarks of an Impressionist painting. It shows people enjoying themselves on a hot summer's day. The surface of the picture is a scintillating mosaic of broken brushstrokes. But it is the colour that is most astonishing – surely no earlier

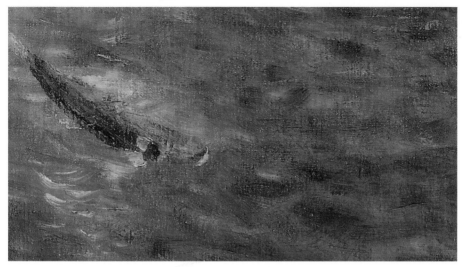

Modern Art, detail

landscape painting uses such vibrant colours.

The Skiff is a genuinely modern painting. It is composed of just seven intense pigments: cobalt blue, viridian, chrome yellow, lemon yellow, chrome orange, vermilion and red lake, together with lead white, used in itself as a pure white paint and for colour tints. Most of these colours were nineteenth-century discoveries, and allowed artists to create much more intense colour effects than had previously been possible. Renoir also had the benefit of metal paint tubes, another recent development, which made painting out of doors more convenient and allowed him to work rapidly. Many of the colours used in *The Skiff* are unmixed, squeezed straight from the tube.

But the brilliance of the picture is not just the result of the pigments themselves. Renoir has taken to heart the work of the influential nineteenth-century colour theorist, Michel Eugène Chevreuil, who in 1839 formulated the law of the simultaneous contrast of colours. This law explains that when pure colours are juxtaposed, the differences between them are enhanced. The effect is most marked when the colours are complementary – colours that appear opposite each other on the colour wheel, such as red and green, yellow and purple, and blue and orange. Renoir's skiff is painted in shades of chrome yellow and lemon yellow, outlined in thick strokes of pure opaque chrome orange, and set against a background of pure cobalt blue, mixed with white where the tone is lighter, to represent the surface of the river. By exploiting the effects of simultaneous contrast, Renoir heightens the colour intensity of his picture and conveys the brilliance of summer sunlight as no previous painter had done.

▶ SEE CHAIRS, RED MONSTER, TOPSY-TURVY

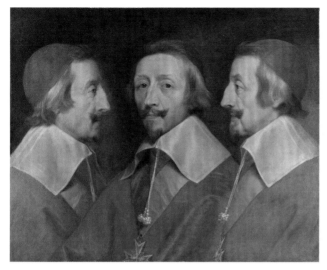

Mugshot

PHILIPPE DE CHAMPAIGNE AND STUDIO,
TRIPLE PORTRAIT OF CARDINAL DE RICHELIEU,
PROBABLY 1642

For us, the combination of a profile and full-face portrait suggests a criminal's mugshot. In the nineteenth century it was a format beloved of anthropologists in their scientific records of 'primitive' peoples. So why would a powerful man like Cardinal Richelieu, First Minister of France under Louis XIII, have his portrait painted three times over from different viewpoints? Like the mugshot and the anthropological photograph, it was intended to record the face of the cardinal with as much accuracy as possible. This is because the picture was to be sent to Rome as a model for the sculptor Francesco Mochi, to help him produce a true likeness of the cardinal in three dimensions. A similar painting of Charles I was done by Van Dyck as a model for the sculptor Bernini. Had the camera existed, a photograph would no doubt have served as well. Someone has annotated Richelieu's portrait to help the sculptor. Over the central head an inscription declares that it is the most true-to-life image, while over the right-hand head it says that, of the two profile views, 'this is the better one'.

▶ SEE BEARD FOR BOLOGNA

Mystery

DIEGO VELÁZQUEZ, CHRIST IN THE HOUSE
OF MARTHA AND MARY, PROBABLY 1618

In the background of Velázquez's kitchen scene, enclosed within a dark framing rectangle, is a picture within a picture of Christ with Martha and Mary. This scene represents the episode in the Gospel of Saint Luke when Christ rebukes the hard-working Martha for complaining that she has been left to serve alone. We are presumably meant to apply this message to the sullen kitchen

maid in the foreground who looks as though she is being given a talking to by her mistress. But what are we to make of the insert behind them? Is it a picture? But what kitchen would have what seems to be an oil painting on its walls? Or could it be a mirror, reflecting what the maid and her mistress are looking at, or a hatch through to a room beyond? A mirror of this size and quality would have been a rare luxury in the early seventeenth century. And if this is meant to be a real scene rather than a painting, how do we square the biblical robes of Christ, Martha and Mary with the contemporary dress of the women in the foreground? In spite of the astonishing realism of the kitchen scene, with its still life of foodstuffs and vessels, Velázquez has given us few clues when it comes to the enigmatic background, preferring instead to leave us guessing.

▶ SEE PATIENCE AND MEEKNESS

[Art] dipped the Spaniard's brush in light and air, and made his people live within their frames, and stand upon their legs.

James Abbott McNeill Whistler about Velázquez

Number 1

Number 1

SEBASTIANO DEL PIOMBO, THE RAISING
OF LAZARUS, ABOUT 1517–19

In 1824 *The Raising of Lazarus* came to
form part of the founding collection of
the National Gallery and is listed 'NG 1'
in the inventory of the collection. But
the painting hasn't always had the
number 1 slot.

Artistic life in Rome in the early
sixteenth century was anything but
harmonious. There was bitter rivalry
between the two giants of the day –
Raphael and Michelangelo – and their
respective followers. The Venetian
painter Sebastiano was inevitably drawn
into this rivalry when he came to
Rome in 1511 and was befriended by
Michelangelo. It was perhaps thanks
to the influence of Michelangelo that
Sebastiano was commissioned in 1516
by the new Bishop of Narbonne, Giulio
de' Medici, to paint this altarpiece of
the raising of Lazarus for Narbonne

Cathedral. The painting was to be a
companion piece to a *Transfiguration*
already ordered from Raphael. Wishing
to see his young protégé outshine
Raphael, Michelangelo supplied him
with drawings for the figure of Lazarus
and the men who are lifting him from
his tomb, and possibly other parts of
the picture as well. The completed
altarpiece was revealed to great acclaim
in 1519, but when it was exhibited
alongside the *Transfiguration* shortly
after Raphael's death in April 1520,
Giulio de' Medici chose to keep
Raphael's painting with him in Rome
while sending Sebastiano's off to
Narbonne, no doubt to Michelangelo's
deep mortification.

▶ SEE BEARD FOR BOLOGNA, FAVOURITE,
LOST AND FOUND

O&P

Orb, Phantom, Poetic Licence …

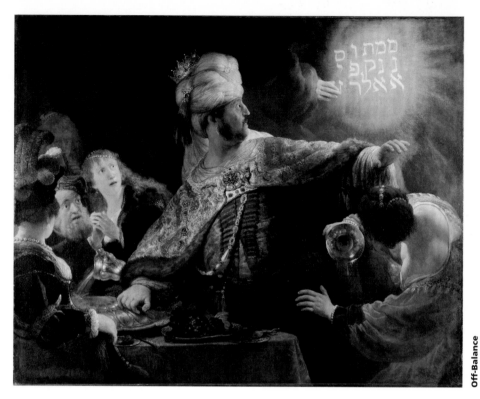

Off-Balance

REMBRANDT, BELSHAZZAR'S FEAST, ABOUT 1635

The Babylonian king, Belshazzar, stands transfixed as a mysterious hand traces in glowing letters the words which prophesy his downfall. Around him all is confusion as vessels of wine are spilt and the king's companions recoil in astonishment. The whole composition seems to teeter on the point of collapse, as if an earthquake had struck. The woman on the right falls towards us, Belshazzar topples backwards and the table tilts. No doubt Rembrandt intended to create this effect, but it goes beyond the bounds of logic. The wine pouring from the upturned goblet held by the woman in red doesn't fall straight down, but at an angle. But all can be explained. At some point in its history the canvas was remounted on a new stretcher slightly askew, with an anti-clockwise twist, and the edges cut down. As Rembrandt painted it, the table top would have been parallel to the bottom of the picture, Belshazzar would have stood erect, and the wine would have fallen vertically. We don't know if the alteration was an accident or intentional, but without a doubt it adds to the turbulence of the scene and the sense that we are witnessing a moment of divine judgement.

▶ SEE FABRICATED, GENIAL COMPANIONS

Orb, detail

Orb, infrared

Orb

ENGLISH OR FRENCH (?), THE WILTON DIPTYCH,
ABOUT 1395–9

Even in famous paintings new things
can be discovered. One of the most rare
and precious objects in the Gallery is
The Wilton Diptych, an exquisite portable
altarpiece made for King Richard II of
England. Richard is shown with three
patron saints, kneeling before the Virgin
and an assembly of angels, one of whom
holds a banner with the flag of Saint
George. When the picture was being
examined under the microscope (top
left, with infrared reflectogram beneath)
in 1992 it was found that the orb at the
top of the banner contains a tiny image

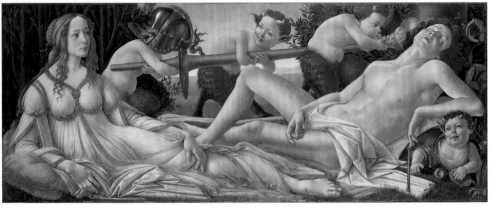

Pale Imitation

of a green island with a white castle and trees, set in a sea of silver-leaf on which is a ship in full sail. The orb measures only 1 cm in diameter but it is crucial to the meaning of the picture. We know that there was a large altarpiece in Rome in the seventeenth century showing Richard offering a globe with a picture of England to the Virgin as her dowry. It contained a Latin inscription that read: 'This is your dowry, O Holy Virgin, therefore rule over it, O Mary.' From this we can deduce what's going on in the *Wilton Diptych*. Richard has just presented the banner with the representation of England to the Virgin who holds her son. The Christ Child has apparently taken it and passed it to the angel, and will now bless Richard who will then receive back the banner in a reciprocal gesture of feudal exchange so that he can rule England under the protection of the Virgin.

Is it even possible that Shakespeare knew of this hidden detail? In his play *Richard II*, John of Gaunt delivers a famous speech in which he describes England as 'this little world, this precious stone set in the silver sea.'

▶ SEE KINGDOM COME, REUNITED, VISION

Pale Imitation

SANDRO BOTTICELLI, VENUS AND MARS, ABOUT 1485 (LEFT)
FOLLOWER OF BOTTICELLI, AN ALLEGORY, PROBABLY ABOUT 1480–1500 (RIGHT)

In June 1874 the collection of Alexander Barker was auctioned and the National Gallery successfully bid for several of his Italian paintings. In addition to Piero's *Nativity* and paintings by Crivelli, Tura and Pintoricchio, two Botticellis were bought – or so it seemed. *Venus and Mars*, now perhaps the most admired painting by Botticelli in the collection, was purchased for £1,050. *An Allegory*, which was then thought to be a companion to *Venus and Mars*, cost

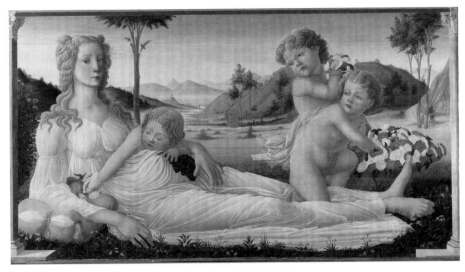

Pale Imitation

£1,627 10s. Today you will search the main floor galleries for this painting in vain. It has long since been relegated to the category of 'feeble imitator of Botticelli' and banished to the basement. Looking at it, it is hard to credit how, with its awkward poses and mask-like faces, it could ever have been thought to be worth more than the supremely elegant and sophisticated *Venus and Mars*.

▶ SEE FAKE, HAT TRICK

Patience and Meekness

PIETER DE HOOCH, THE COURTYARD OF A HOUSE IN DELFT, 1658 (OVERLEAF)

Every detail of de Hooch's *Courtyard of a House in Delft* is so realistically painted that it's easy to believe that this courtyard and these people actually existed. Although de Hooch recreated the essence of the Delft he knew, we don't know how much of this scene he invented. But we know for a fact that the inscription over the arched doorway existed, as it has survived to this day, in the hall of a private house in Delft. Dated 1614, it commemorates the Augustinian Monastery of Saint Hieronymous, most of which had been destroyed in a fire in 1536. It reads in translation: 'This is Saint Jerome's vale, if you wish to retire to patience and meekness. For we must first descend if we wish to be raised.' Although the lady of the house seems to be waiting patiently in the passage that leads to the street, de Hooch must have meant the inscription to be a commentary on the maid in the courtyard who attends to the little girl with kindness and patience. Each of them seems to be carrying something, the maid in the bowl cradled in her arm, and the girl in her bunched up apron. Perhaps they have been gathering fruit from a garden beyond the open gate in the wall on the right.

▶ SEE DISTORTION, PHANTOM, THUNDERCLAP

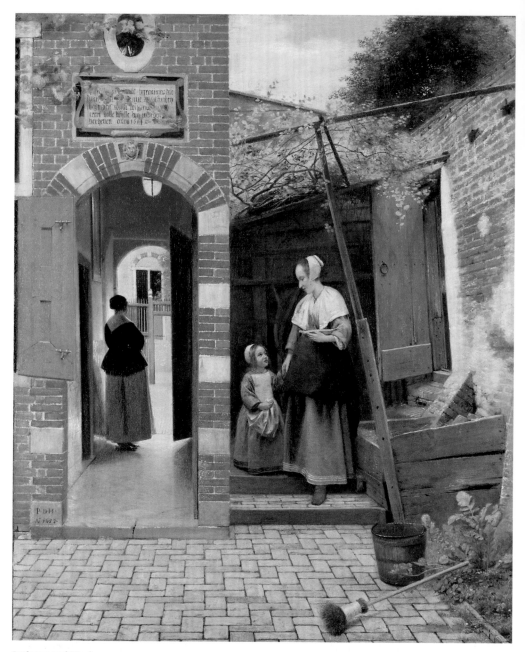

Patience and Meekness

Performance Art

JOSEPH WRIGHT OF DERBY, AN EXPERIMENT
ON A BIRD IN THE AIR PUMP, 1768

What is going to happen to the white
cockatoo in Wright's painting of *An
Experiment on a Bird in the Air Pump*?
Will it live or die? The 'scientist' has
pumped out the air from the glass globe
in which the bird is trapped, and is
poised to revive it by releasing the
valve at the top.

Wright's picture has often been taken
as evidence of the progress of science
in the late eighteenth century, but sadly
his science is old-hat, not cutting-edge.
The scientist Robert Boyle had first
demonstrated the effects of a vacuum
over a century before, in Oxford in 1659,
when he witnessed a bird in his air pump
collapse in convulsions and die as the air
was withdrawn. Wright is showing us
science performed as a parlour trick for
entertainment. He is chiefly concerned
with the drama of the demonstration

and the reactions of his spectators –
from the concentration of the young
man on the left, to the distress of the
two girls (whose pet bird is in danger),
to the philosophical detachment of
the older man on the right. The self-
absorbed lovers on the left may well
be Thomas Coltman and Mary Barlow
who married in 1769, the year after
Wright painted this picture, and who
form the subject of a double portrait by
Wright, also in the National Gallery.

▸ SEE ENIGMA

Phantom

PIETER DE HOOCH, A WOMAN DRINKING
WITH TWO MEN, PROBABLY 1658

Working out how a painting evolved
is a little like archaeology – you have
to search beneath the surface to reveal
earlier traces. In this picture the effects
of time have made the process of
discovery easier. Because the top layer

Phantom

of paint has become less opaque with age, it is actually possible to see what lies underneath, and to follow some of the artist's revisions. We can tell that de Hooch first painted the room with its tiled floor and beamed ceiling, and then added the figures. The chequerboard pattern of the tiles shows clearly through the seated man's cloak and the maid's blue skirt. A slight halo behind the man with a hat shows that he was once larger or positioned further to the right, and the chimney-breast has been painted over the beams at the top. Most mysteriously, a ghost of a man stands to the left of the maid, the crown of his hat just visible against the chimney-piece and his foot against the floor. In this instance the fireplace and the floor are painted on top of the figure to conceal him. But did the maid replace the man when he was painted out, or did they once stand together side by side?

▶ SEE MYSTERY, PATIENCE AND MEEKNESS, X-RAY

Poetic Licence

JOHANN ZOFFANY, MRS OSWALD, ABOUT 1763-4

It is dangerous to offend a poet, even when the offence is caused posthumously. After Mrs Oswald, the subject of Zoffany's portrait, died in London on 6 December 1788, her body was taken back to Scotland to be buried beside that of her husband. When the funeral cortège had nearly reached its destination, a blizzard forced it to seek shelter in an inn where, by coincidence, the poet Robert Burns was also taking refuge. When the cortège took possession of the inn, he was forced to ride home through the storm. In his fury he penned an 'Ode, Sacred to the Memory of Mrs Oswald of Auchincruive' in which he pictured the widow's descent to hell, 'Laden with unhonour'd years / Noosing [nursing] with care a bursting purse / Baited with many a deadly curse!', there to meet the 'plunderer of armies', her deceased husband.

Poetic Licence

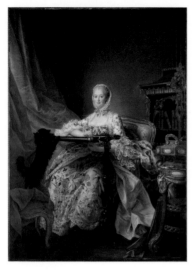

Posthumous

Burns did not know Mrs Oswald personally but in a letter he states: 'I spent my early years in her neighbourhood, and among her servants and tenants I know that she was detested with the most heart-felt cordiality.' He must have known the role that Mrs Oswald's husband, Richard, the 'plunderer of armies', had played in the Seven Years War and the American War of Independence, profiteering as an army supplies contractor. He may also have known that both her fortune and much of her husband's came from extensive estates in the West Indies and the southern states of America, and that they were actively involved in the slave trade. They built a fine mansion, designed by Robert Adam, at their estate of Auchincruive, near Ayr in Scotland, and it is there, in the chilly sunshine, that the dour-faced Mrs Oswald sits in Zoffany's portrait. It is tempting to think that Burns had seen the painting when he wrote his savage verse and asked his reader: 'View the weathered beldam's face / Can thy keen inspection trace / Aught of humanity's sweet melting grace?'

▶ SEE EYEBROWS, POSTHUMOUS, RELUCTANT SITTER

Posthumous

FRANÇOIS-HUBERT DROUAIS, MADAME DE POMPADOUR AT HER TAMBOUR FRAME, 1763–4

By the time this splendid portrait of the notorious Madame de Pompadour, mistress of King Louis XV, was completed, the sitter was dead. The marquise was suffering from an incurable illness and she died on 5 April 1764 at the age of 43. This is the last of a magnificent series of portraits of the marquise by some of the greatest French painters of the day. It bears an inscription on the table to the right, which translates as, 'Painted by Drouais, the head in April 1763 and the painting finished in May 1764.' The content' of the inscription is corroborated by physical evidence, as the head and bust are

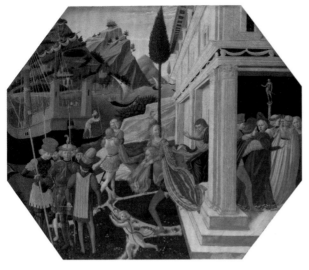

painted on a separate piece of canvas which, as can be detected on close viewing, was let in to the larger canvas. Given her declining health, it seems unlikely that the marquise would have been able to give Drouais many sittings, and once the head was completed to her satisfaction, it is probable that a model, perhaps a lady in waiting, would have put on her sumptuous embroidered dress and taken her place.

▸ SEE CELEBRITY GEORGIAN STYLE, FASHIONABLY LATE

Power of Love
ATTRIBUTED TO ZANOBI STROZZI, THE ABDUCTION OF HELEN, ABOUT 1450–5

It's only just been discovered what this picture was made for. Historians thought that it could have been part of a marriage chest or similar piece of furniture, but technical examination has shown that it was originally twelve-sided, the traditional shape for a *desco da parto*, or birth tray. Birth trays were originally used in Florence for bringing refreshments to women just after they have given birth, and later displayed to commemorate the event. They led to the development of the *tondo*, the circular form of painting that became so popular in Florence later in the fifteenth century.

At first sight, the subject of the abduction of Helen, wife of Menelaus, by the Trojan prince Paris hardly seems appropriate, but the theme that many such birth trays have in common is the power of love. The source from which Strozzi took his subject, a first century account of the Trojan Wars by Dares Phrygius, tells that Helen and Paris fell passionately in love at first sight, and that Helen was willingly abducted, along with several other women.

This *desco da parto* has been extended at various places around the edges to transform it into an octagon. A small

hole in the centre, visible under X-ray, shows where the panel-maker used a compass to construct the original twelve-sided polygon. It would have been painted on the reverse as well, but the back has been planed down, probably when the panel was altered.

▶ SEE GEOMETRY, X-RAY

Prison Food

GUSTAVE COURBET, STILL LIFE WITH APPLES AND A POMEGRANATE, 1871–2

Courbet's art is a celebration of the humble realities of peasant life, and this still life of ruddy apples in an earthenware bowl with a pewter tankard would appear to fit that description. But the reality it reflects is altogether more grim, since it was painted in the Paris prison of Saint-Pélagie. How Courbet came to be imprisoned is well documented. During the Paris Commune of 1870–1 he served as a councillor and was involved in the destruction of the Vendôme Column – considered a symbol of Napoleonic Imperialism. After the Commune was suppressed, he was arrested, fined 500 francs and sentenced to six months' imprisonment. At Saint-Pélagie, Courbet was visited by his sister Zoé who brought him fruit and flowers which aroused in him a desire to paint again. He was allowed brushes and paint, and in spite of poor health, began to paint a series of still lifes, of which this picture, with its sombre colouring and humble utensils, is one. After his release he was required to pay the costs of the rebuilding of the column: a fine of over 300,000 francs in yearly instalments of 10,000 francs. He fled to Switzerland to escape bankruptcy, and died 31 December 1877, a day before the payment of the first instalment was due.

▶ SEE CENSORSHIP, EXILES

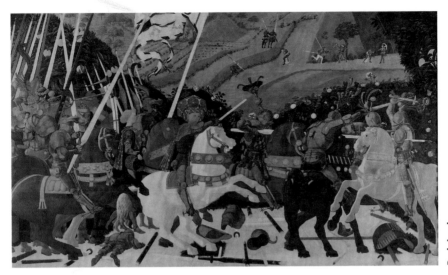

Purloined

PAOLO UCCELLO, THE BATTLE OF SAN ROMANO,
PROBABLY ABOUT 1438–40

One of the privileges of being a powerful ruler is that you don't have to be too scrupulous about how you acquire riches – or works of art. Since the early records all show Uccello's *Battle of San Romano* and its two companion battle scenes in Paris and Florence as belonging to the Medici family in Florence, it has always been assumed that they must have been commissioned by a member of the family, established patrons of the arts, and that it was probably Cosimo de' Medici. But documents have recently been discovered proving that they belonged originally to another Florentine family, the Bartolini Salimbeni, from whom they were seized by Lorenzo de' Medici. On 30 July 1495, Damiano Salimbeni claimed that he and his brother had been the joint owners of the paintings, that his brother had been

persuaded to make over his share to Lorenzo, and that when Damiano refused to do likewise, Lorenzo sent a woodworker to their house to forcibly remove the works. So that they could be fitted into Lorenzo's rooms in the Medici Palace, the top of each panel had to be cut off. Technical examination shows that the tops were once arched to fit a vaulted room, presumably one in the Bartolini Salimbeni town house for which the paintings were made. Once the paintings were reduced in height, new corner pieces were added at the tops to make them into regular rectangles. The measurements of the paintings given in the inventory of Lorenzo's collection in 1492, after his death, roughly correspond to their shape and size today. We can only guess at what has been lost from the scene – a hilly horizon perhaps, and a glimpse of sky pierced by the tops of the lances and banners.

▶ SEE DROP-FOOT, GREAT ESCAPE

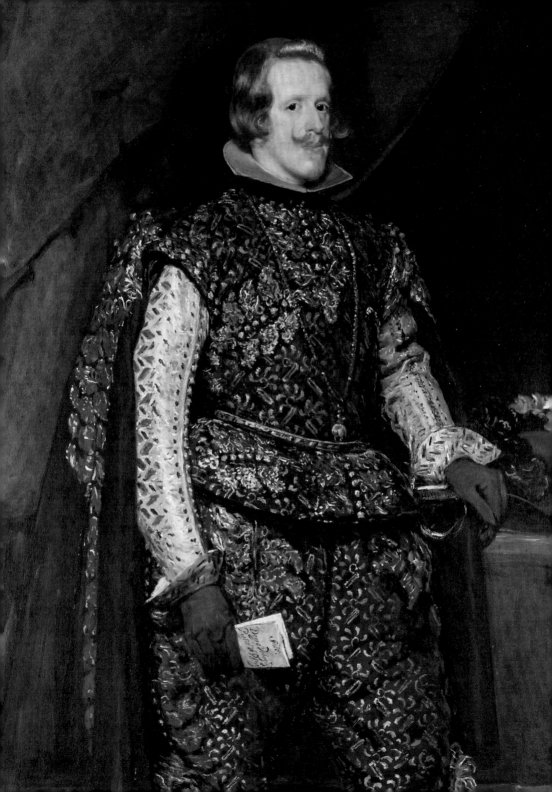

Q&R

Quixotic, Rescued, Rhinoceros…

Quixotic

STUDIO OF PETER PAUL RUBENS, PORTRAIT OF
THE ARCHDUKE ALBERT, AND PORTRAIT OF THE
INFANTA ISABELLA, BOTH PAINTED BEFORE 1615

When Richard Charles Jackson died
in 1923, he had only 5 shillings in his
bank account and 6s 8d in his pocket.
Everything in his house in South
London was 'in an indescribable state
of confusion, filth and neglect'. Yet the
contents included Old Master paintings,
valuable ornaments and thousands of
books, which sold for £12,000. Jackson
left two paintings – portraits of the
Archduke Albert and Archduchess
Isabella of Austria from the studio
of Rubens – to the National Gallery.
Jackson had been born to wealth but
gave all of it away. He could be seen
nightly on the Thames Embankment
handing out food and money to the
homeless. He was deeply religious and
as he grew older became increasingly
withdrawn and eccentric. He would

wear priestly robes and celebrate Mass
on his own, believing himself to be a
bishop of the Greek Orthodox Church.
In his youth, before his eccentricities
became so marked, Jackson had been
a friend of the aesthete and writer
Walter Pater, and is said to have been
the inspiration for the hero of Pater's
novel *Marius the Epicurean*, a Roman
from the second century who devotes
his life to the pursuit of beauty.

▶ SEE DIPLOMACY, HERO WORSHIP, JIGSAW

Race

J.M.W. TURNER, RAIN, STEAM AND SPEED –
THE GREAT WESTERN RAILWAY, BEFORE 1844

Which is faster – a hare or a train? Not
a riddle, but the question that Turner
puts to us in his painting *Rain, Steam and
Speed*. Not much is clearly discernible
in the painting. Veils of light and vapour
obscure the landscape so that only the
black chimney stack of the train remains

Race

sharply defined. But we do know that the painting shows one of the Firefly class of trains heading westward from London and crossing the great double-arched Maidenhead Railway Bridge, built in 1837–8 by Isambard Kingdom Brunel.

On the track in front of the train, but hard to see, a hare races to escape the approaching juggernaut. It's likely to be a close-run thing. A jack hare can achieve speeds of up to 45mph. The average speed of the Firefly on the Great Western Railway was 33mph, but it was known to reach 55 or even 60mph on this stretch of line. Will the hare survive?

▶ SEE EXILES, LAST VOYAGE

A tortoiseshell cat having a fit in a platter of tomatoes.

Mark Twain on Turner

Red Monster

EDGAR DEGAS, COMBING THE HAIR
('LA COIFFURE'), ABOUT 1896

'The big red monster' is how one critic described this late painting by Degas, and with good reason. It is painted overwhelmingly in shades of red, orange and pink. The fiery tones are only relieved by the whites of the maid's apron, the woman's collar and cuffs, and the tablecloth with its hints of mauve and green. In his late work Degas became more and more experimental, using bold colour for expressive purposes, but did he really mean to leave this picture looking like this? It is obviously not finished in a conventional sense. There are patches of bare canvas, some of the objects on the table are merely sketched in outline, and the work is unsigned. Degas restretched the picture to expose more of the canvas with a view to enlarging the composition, but he never got as

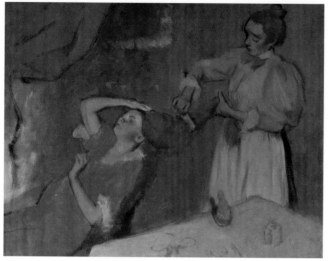
Red Monster

far as painting the additional areas, and after his death the painting was returned to its original shape and size. So did Degas really mean the painting to be so red? Maybe not. There is a painting, *A Group of Dancers* (1890s), by Degas in the National Gallery of Scotland, also from the 1890s, in which he added strongly contrasting blues, greens and whites on top of an underpainting of red – so he may have planned to relieve the reds in this painting in the same way. But, in spite of the fact that Degas lived another 20 years and the picture remained in his studio, he didn't change it. Whatever his original intentions, he opted to leave 'the big red monster' be.

▶ SEE FIRST IMPRESSIONS, MODERN ART, TOPSY-TURVY

Reluctant Sitter

SIR THOMAS LAWRENCE, QUEEN CHARLOTTE, 1789

Painting royalty must be intimidating, especially when you are the youngest son of a country innkeeper trying to establish a reputation in the metropolis. Lawrence was only 20 when he painted Queen Charlotte in the autumn of 1789, and he does not appear to have established a good rapport with his sitter. The queen was no longer young and, according to Mrs Papendiek, assistant keeper of the Queen's wardrobe, she had not fully recovered 'from all the trouble and the anxiety she had gone through' as a result of the onset of George III's mental illness. Lawrence found her solemn and glum, and, in an effort to animate her, suggested that she talk. This she found 'rather presuming'. As X-ray photographs of the painting show, Lawrence had to resort to his own

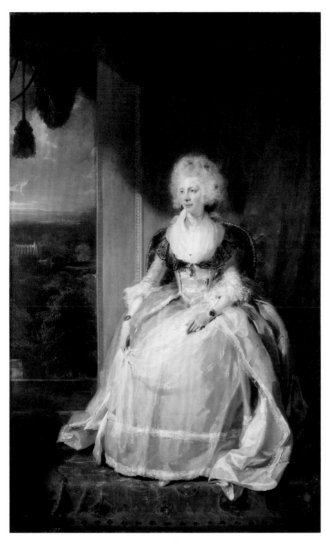

Reluctant Sitter

I do not understand the reputation of
this painter ... The mouth of his portrait
of a woman looks like a small piece of
red ribbon glued to the canvas.

Stendhal on Lawrence

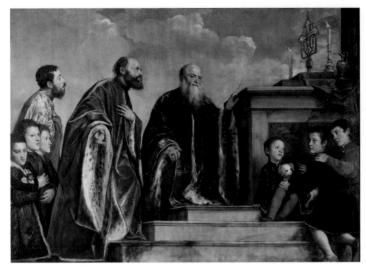

Rescued

invention to instil some degree of
liveliness into her expression, giving
her a half-smile where there was none.
Lawrence also took a dislike to the
bonnet she proposed wearing and
persuaded her to sit bare-headed, an
effect which the king, when he saw
the picture, found upsetting. This was
hardly surprising as Lawrence had done
nothing to disguise the wildness of her
grey hair. Finally she would sit no more
for him and only after the intervention
of the princesses did the queen allow
Mrs Papendiek to take her place so that
Lawrence could complete the details
of the royal jewellery. The portrait was
shown to great acclaim at the Royal
Academy the following year, where
it was seen by the king and queen.
But they chose not to buy it, and it
remained with the artist until his death.

▶ SEE FASHIONABLY LATE, X-RAY

Rescued

TITIAN, THE VENDRAMIN FAMILY, MID-1540S

Titian's *Vendramin Family* shows the
members of this august Venetian dynasty
venerating an object of particular
significance to them. On the altar on
the right is an elaborate reliquary in the
form of a cross made of gold and crystal,
containing what was believed to be a
fragment of the true cross. When this
reliquary was presented in 1369 to
Andrea Vendramin, Guardian of the
Scuola of Saint John the Evangelist and
ancestor of the men and boys in Titian's
portrait, it fell into the canal. Legend
tells that, miraculously, it remained
suspended above the water until the
devoted and intrepid Andrea Vendramin
jumped into the canal to recover it.
Thanks to his timely intervention, the
relic survived and can still be seen in
the Scuola in Venice.

▶ SEE BEHIND CLOSED DOORS, ENVY,
GENIAL COMPANIONS

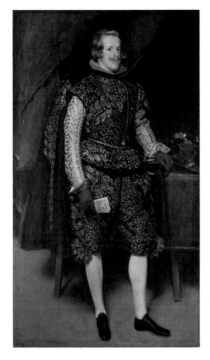

Respectful Distance

DIEGO VELÁZQUEZ, PHILIP IV OF SPAIN, ABOUT 1631–2

Velázquez was important to Manet and the Impressionists because his free handling of paint showed them how they could challenge the dry and fussy methods used by academic painters. In this portrait Velázquez shows Philip IV in an unusually rich costume which shimmers in the light, but which on close examination becomes quite abstract. With a mixture of smudges and squiggles of paint, he conjures up the textures of embroidered fabrics, lace and jewels. How did Velázquez achieve these extraordinary painted effects? The answer, according to his biographer Antonio Palomino, was the use of long-handled brushes – a trick adopted centuries later by Monet when working on his water-lily canvases. By using these brushes (up to 250 cm long according to some reports), Velázquez could see what his marks would look like at a distance as he was painting them. This supremely skilful artist understood the power of the eye to complete that which is suggested to it, and devised an ingenious method to achieve his effects.

▶ SEE DIPLOMACY, HOLIDAYS

Reunited

ITALIAN, UMBRIAN (?), DIPTYCH, ABOUT 1260

No-one knows how long these two thirteenth-century panels had been separated. The *Man of Sorrows* was first

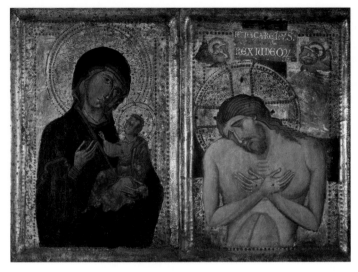

Reunited

recorded in a sale in 1926, and the *Virgin and Child* in a sale in 1989 – where it was wrongly catalogued as dating from the nineteenth century. In 1948 an American scholar noticed three hinge marks on the left edge of the *Man of Sorrows* and rightly deduced that the panel was the right wing of a diptych (a portable work consisting of two panels). 50 years later a photograph of an unidentified *Virgin and Child* was sent to Joanna Cannon at the Courtauld Institute in London. A little later she encountered a photograph of the *Man of Sorrows* and was struck by the punching on the haloes and the borders. Comparing the same details on the mystery picture she had been sent, she saw they were identical and deduced that the paintings belonged together. She alerted the National Gallery and when the pictures were finally brought together, it was obvious that they were a pair. They are exactly the same size, the hinge marks match up, and the backs are

both painted in imitation of red porphyry (a hard stone sometimes used for sculpture).

Who painted these panels remains a mystery, but they represent the earliest surviving example of the *Virgin and Child* and the *Man of Sorrows* in a diptych. The *Man of Sorrows* is one of the first images of its kind in Italian painting. By remarkable good fortune the National Gallery succeeded in buying both paintings – so they can now be seen together, as the artist intended when he painted them over 700 years ago.

▶ SEE MELODRAMA, ORB

Rhinoceros
PIETRO LONGHI, EXHIBITION OF A RHINOCEROS AT VENICE, PROBABLY 1751

The rhinoceros in Longhi's painting could well claim to be the most celebrated rhinoceros that has ever lived. It was the fifth recorded in Europe since Roman times. The first, which is

Rhinoceros

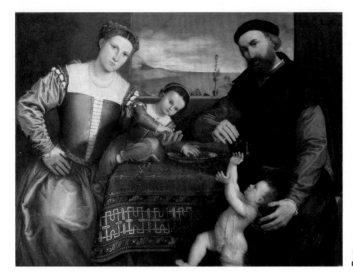

Rug

commemorated in a woodcut by Dürer, arrived in Lisbon in 1515 and was sent as a present by the king of Portugal to Pope Leo X. Unfortunately the ship it sailed on was wrecked off Genoa and it drowned. A second rhino arrived in Madrid later in the sixteenth century and two came to London in 1684 and 1739. But it was the fifth, 'Miss Clara' as she became known, who induced a veritable 'rhinomania' throughout Europe. Trapped in Assam and presented to the director of the Dutch East India Company in Bengal, she was sent to Holland in 1741 and toured Europe for 16 years. Frederick the Great saw her in Berlin, Augustus III, King of Poland and Elector of Saxony, in Dresden, and the Empress Maria Theresa in Vienna. Her owner, a Dutch sea captain, was made a Baron of the Empire. Poems were written about her, medals struck and clocks, coins and ribbons made in her honour. The

artist Jean-Baptiste Oudry painted her, she appeared on a tapestry produced by the famous Gobelins factory in Paris, and she even inspired a hairdo with a feather horn. Casanova tells a story that his mistress mistook the rhino's dark-skinned and muscular attendant for the rhinoceros itself. In London, Clara was exhibited with two dwarfs, a contortionist and a crocodile, and in Venice in 1751 she was the star of the Carnival. In Longhi's painting she seems to be unmoved by all the fuss, too bothered perhaps by the loss of her horn, which is held aloft by the attendant, to pay any attention to her admirers.

▶ SEE THOROUGHBRED

Rug

LORENZO LOTTO, PORTRAIT OF GIOVANNI DELLA VOLTA WITH HIS WIFE AND CHILDREN, COMPLETED 1547 (ABOVE)
HANS HOLBEIN THE YOUNGER, 'THE AMBASSADORS', 1533 (OPPOSITE)

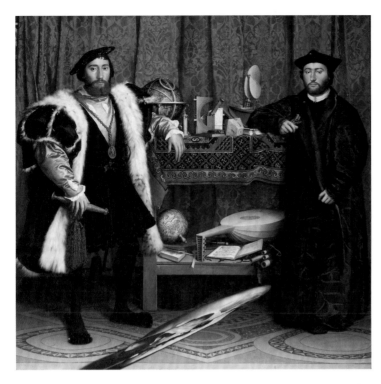

Rug

Lotto, like the artist Holbein, has the distinction of having given his name to a type of Turkish carpet. The 'Lotto' rug takes its name from this portrait of a family group – probably Giovanni della Volta and his wife and children – where it covers the table. Lotto painted the rug so accurately that we can identify it with the 'arabesque Ushak', a type of Turkish rug from Western Anatolia that became popular in Italy in the sixteenth century. The rug has a lattice design, usually in saffron yellow on a red madder ground, and a distinctive Kufic (an early form of the Arabic alphabet) border of pale interlaced lines against a dark background. The first Italian artist to include a rug of this type in his paintings was Sebastiano

del Piombo in a work of 1516, but Lotto shows them more frequently and it is his name that has become attached to them.

Turkish carpets were luxury items in the West, and are an indication of wealth and splendour where they appear in paintings. The carpet which is shown with other costly items in Holbein's '*Ambassadors*' – a type from North-Western Anatolia which crops up quite frequently in both Italian and Northern paintings of this date – became known as a 'large-pattern Holbein' from its appearance here.

▶ SEE ANONYMOUS, FEATHERS AND FUR, NUMBER 1

S

Silver, Skull, Soaked …

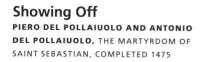
Showing Off

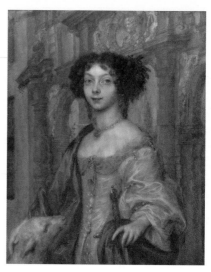
Silver

Showing Off

PIERO DEL POLLAIUOLO AND ANTONIO DEL POLLAIUOLO, THE MARTYRDOM OF SAINT SEBASTIAN, COMPLETED 1475

In order to prove that they were better than painters, sculptors of the Renaissance liked to point out that they could reproduce a figure that could be viewed from all sides, whereas the painter could only show one aspect of a body at once. But some painters were very inventive. In his *Lives of the Artists*, Giorgio Vasari tells how the artist Giorgione ingeniously painted a picture of a man with his front view reflected in water and his two side views in a piece of armour and a mirror.

The Pollaiuolo brothers attempted something similar to Giorgione in their altarpiece *The Martyrdom of Saint Sebastian*. The picture acts as an advertisement for their skill as painters of the human figure, landscape, horses, archaeology and perspective. Three of the standing archers are really the same

person seen from different angles, as are the two bending figures re-loading their crossbows – one seen from the front, the other from behind. Even the horses in the middle distance are paired, the brown ones facing forward and back, and the prancing white ones to each side. The final effect is somewhat stylised, with the painters' determination to demonstrate an academic point.

▶ SEE PURLOINED

Silver

GONZALES COQUES, PORTRAIT OF A WOMAN AS SAINT AGNES, ABOUT 1680

We tend to assume that artists have always painted on canvas, but in reality they used whatever was to hand or suited their purposes: wooden panels of poplar, oak and mahogany, paper, card, and fabrics of every kind – even, when times were hard, the coarsest sack cloth. Metal supports were used too.

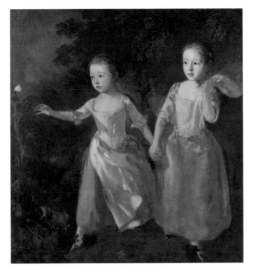

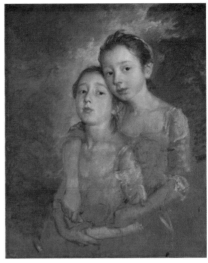

Copper was especially popular in the seventeenth century. But this painting by the seventeenth-century Flemish painter Coques is unique among the works in the National Gallery because it is painted on a sheet of silver. Why would anyone go to such expense when the silver was to be covered by paint? Silver may have been chosen to give a luminosity to the painting itself – the colours are exceptionally silvery, from the shimmering whites of the dress and the pale flesh tints to the pearly greys of the portico in the background.

Given the expense of the painting surface, this object must have been prized by the owner, who was possibly a relation of the woman in the picture and may have carried the delicate painting around. Saint Agnes was the patron saint of virgins and young girls so perhaps this image was a reminder of a much-loved daughter. Or perhaps the sitter's name was Agnes.

▶ SEE FABRICATED, JIGSAW

Sisters

THOMAS GAINSBOROUGH, THE PAINTER'S DAUGHTERS CHASING A BUTTERFLY, PROBABLY ABOUT 1756 (LEFT) AND THE PAINTER'S DAUGHTERS WITH A CAT, 1760–1 (RIGHT)

Gainsborough loved to paint his daughters Mary and Margaret ('Molly' and 'The Captain', as he affectionately called them) and there are two paintings of them in the National Gallery. In one they run, grasping at a passing butterfly, in the other they tweak the tail of a cat. The cat is only a ghost-like presence because Gainsborough didn't finish the painting, but the faint drawing clearly shows what is going on.

Innocent enough pursuits, but it is hard to look at these pictures without remembering the fate of these little girls. From an early age Mary suffered from a recurring mental illness which most of the physicians Gainsborough consulted said, perhaps rightly, was inherited. Mary had a short-lived

> I am sick of portraits and wish very much to take my viola-da-gamba and walk off to some sweet village where I can paint landskips.
>
> Gainsborough

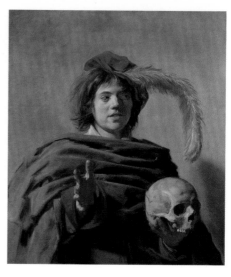

marriage to a temperamental oboe player and, after the death of her parents, ended up living with her sister. In 1818 a friend described Margaret as 'odd' and Mary as 'quite deranged'.

▶ SEE DEATH, DEEP POCKETS

Skull

FRANS HALS, YOUNG MAN HOLDING A SKULL (VANITAS), 1626–8

'Alas poor Yorick! I knew him, Horatio.' These words from *Hamlet* could be the caption to this picture by Hals, painted just 25 years or so after Shakespeare wrote the play. With his hand dramatically outstretched into our space, the young man might well be an actor declaiming on the stage. There is no evidence to support such a connection or to say that Hals knew of Shakespeare and his plays. What Shakespeare's play and Hals's painting have in common is that they both refer to a tradition in which a young man holding a skull serves as a *vanitas*, a reminder of the transience of human life and its pleasures. Hals's young man is an emblem of this type, and to underline his symbolic character he wears fanciful costume, introduced to Holland by followers of the painter Caravaggio. The painting has more than a whiff of greasepaint about it, serving only to reinforce the inevitable association with *Hamlet*.

▶ SEE EXECUTION, DEATH

Soaked

GIOVANNI BATTISTA CIMA DA CONEGLIANO, THE INCREDULITY OF SAINT THOMAS, ABOUT 1502–4

From the moment it was completed in 1504 Cima's altarpiece was a problem picture. The paint was soon flaking off, perhaps because the panel on which it was painted was poorly prepared, or else as a result of neglect. But the real disaster

Soaked

came in the 1820s while it was housed
in the Accademia in Venice after
restoration treatment, when it was
submerged in the waters of the Grand
Canal during a sudden *acqua alta*. When
bought by the National Gallery in 1870,
the painting's condition was described
as 'deplorable', with large areas of the
surface suffering from losses and covered
with repaint. It continued to deteriorate,
despite the efforts of successive restorers,
until, in the 1950s, it was laid flat with
tissue paper stuck over the front to
prevent any more paint loss. By the
1970s, it was established that the paint
was barely attached to the 'ground',
the foundation layer of gesso and animal
glue with which the artist had primed
the painting surface all those centuries
ago. The panel itself was so rotten that
only drastic action could save the
painting. It was decided to remove
the wooden panel from the back and
to reattach the paint layer and gesso

to a new support. The process took
years of painstaking work. Once the
painting was safely attached to its new
panel, the equally laborious process of
retouching the thousands of tiny paint
losses could begin. Finally, in 1986, the
picture went back on show for the first
time in 40 years and, 15 years later, it
was installed in the newly constructed
Sainsbury Wing, where it commands
the magnificent view along the main
east-west axis of the Gallery.

▶ SEE CONSERVATION, FRAMED, MELODRAMA

Split Personality

PONTORMO, JOSEPH WITH JACOB IN EGYPT,
PROBABLY 1518

If a picture shows what appears to be
one space, we usually assume that the
laws governing that space are the same
as in real life, and that an object or a
person can only appear once. For a story
with a number of episodes, we might

expect to see a series of pictures, like a *predella* panel running along the bottom of an altarpiece. But artists can make their own rules. In Pontormo's *Joseph with Jacob in Egypt*, several episodes are ingeniously combined in a single composition, and, in defiance of the laws of nature, Joseph appears four times simultaneously in what seems to be a single space. We can identify him by the clothes he wears – orange tunic, lilac cloak and scarlet cap. In the foreground, on the left, he presents his aged parents to Pharoah; on the right, seated on a chariot, he accepts a petition on behalf of the victims of famine; just above, he climbs the staircase with one of his two sons dressed in green; and in the top right, he presents his sons to be blessed by his dying father.

▶ SEE MELODRAMA

Striptease

PAUL CÉZANNE, BATHERS (LES GRANDES BAIGNEUSES), ABOUT 1894–1905

Lovers of Cézanne's *Bathers* might be surprised to learn that when they see it in the National Gallery they are not getting the full picture. Concealed by the top of the frame is a strip of painted canvas, about 6 cms wide, which is never shown. But this is not a cover up by the Gallery. The additional strip is part of the painting as it existed at an earlier stage in its development. Cézanne originally planned a taller composition with more sky at the top. The shapes of the trees to either side extend across the strip to the top edge. But the strip is paler in colouring and less thickly painted than the finished areas below and has patches of bare canvas showing. At some point Cézanne must have decided on a more horizontal format and restretched his canvas, folding the redundant strip over the top

> In writing songs
> I've learned as
> much from Cézanne
> as I have from
> Woody Guthrie.
>
> Bob Dylan

of the new stretcher. He then continued work, adding more layers of paint and, as photographs of the entire canvas show, making the sky a more intense blue. As it was originally intended, with more space above the bathers, the London painting was closer in format to the largest of the three versions of the *Bathers* that Cézanne painted, now in the Philadelphia Museum of Art. The latter is less thickly painted, with patches of bare canvas showing (like the strip at the top of the London version) and was probably left unfinished when the artist died in 1906.

▶ SEE IDENTITY CRISIS, JIGSAW

Supercilious

SALVATOR ROSA, SELF PORTRAIT, ABOUT 1645

'If you haven't got anything better to say, shut up' could be the caption to this self portrait by Rosa. The Latin inscription at the bottom is in fact rather more diplomatic. It translates as 'keep silent unless your speech is better than silence' and comes from the Greek philosopher and mathematician Pythagoras.

Few self portraits can have been designed to be so unappealing. Rosa has portrayed himself in the cap and gown of a scholar, with an expression that is at once challenging and supercilious. He seems to interrogate the viewer with a fixed stare, furrowed brow and downcast mouth. As well as a painter and etcher, Rosa was a poet, actor, musician and satirist, and in this picture he has portrayed himself as a stoic philosopher casting a disdainful eye on the vanities of the world. His indiscriminate denunciations of the ruling powers, as well as of artists and writers, earned him many enemies in Rome and almost landed him in prison. Legend tells that he escaped to live among the brigands of the remote Abruzzi region of southern Italy,

Survival of the Fittest

where, from the way he portrays himself here, we can imagine he would have felt very much at home.

▶ SEE GENIAL COMPANIONS, HERO WORSHIP, ILLUSIONIST

Survival of the Fittest

PARMIGIANINO, THE MADONNA AND CHILD WITH SAINTS, 1526–7

It is fortunate for us that Parmigianino was the extraordinarily talented painter he was, or this painting may never have seen the light of day. In his *Lives of the Artists*, the painter and writer Giorgio Vasari tells how Parmigianino was working on the *Madonna and Child with Saints* in his studio on 6 May 1527 when Imperial troops of the Holy Roman Emperor, Charles V, entered Rome and began to ransack the city, destroying churches, monasteries and palaces, raping the women, and torturing and killing the men. All but a few of the

Syphilis

Swiss Guard (the Pope's personal guard) were massacred on the steps of Saint Peter's, and the Pope, Clement VII, was held prisoner. When a band of German soldiers broke into Parmigianino's studio and found him at work, he might have been killed as well. But as Vasari tells us, 'when they reached him and saw him at work, they were thunderstruck at the painting which they saw, and, like the gentlemen they must have been, let him continue. And so while the poor city of Rome was being devastated … Francesco was provided for and greatly honoured by those Germans and protected from all harm.' Eventually Parmigianino's uncle succeeded in taking him back to Parma and deposited the painting with a religious order, where it remained in safety.

▸ SEE GEOMETRY, PURLOINED, SHOWING OFF

Syphilis

BRONZINO, AN ALLEGORY WITH VENUS AND CUPID, PROBABLY 1540–50

Bronzino's *Allegory* was intended as a gift for the King of France and is a puzzling picture. There's no doubt that it's a highly charged erotic image, with Venus the goddess of love being embraced and kissed by her son Cupid, but what do all the other figures signify? Old Father Time seems to be drawing a veil to reveal the figure of Oblivion (who has no back to her head). A boy, perhaps Pleasure or Folly, throws flowers while ignoring the thorn that pierces his foot, and behind him Deceit, fair of face but foul of body, offers a honeycomb in one

hand while concealing the sting of her tail in the other. Clearly beneath the smooth surface of love, lurk hidden dangers. But what or who is the tortured figure behind Cupid?

A practising doctor and art historian, Dr J. F. Conway, has put forward a theory that this figure represents the effects of syphilis, a disease which arrived in Europe from the New World in the fifteenth century and had reached epidemic proportions by 1500, spread by invading troops. The term itself was coined in the 1530s, in an epic poem by Girolamo Fracastoro entitled *Syphilis sive morbus gallicus*, or 'Syphilis or The French Disease'. The figure in Bronzino's painting shows all the symptoms of tertiary syphilis in men: skin discolouration, swollen joints, missing nails and mental disturbance. If Dr Conway is right, the painting takes on an altogether more urgent meaning as a reminder of the suffering caused by illicit love.

▸ SEE CODED MESSAGE, DEATH, HIDDEN MEANINGS

T

Thoroughbred, Thunderclap, Topsy-Turvy …

> Stubbs is useful, but his horses are not broad enough in light and shadow for a painter.
>
> Benjamin Robert Haydon

Thoroughbred

GEORGE STUBBS, WHISTLEJACKET, ABOUT 1762

This life-size horse, without bit, bridle, saddle or rider, rearing against a plain background, has no precedent and is an astonishing subject for a painting. But is Stubbs's portrait of the Arabian horse Whistlejacket finished? According to Stubbs's early biographer, Ozias Humphrey, the painting was commissioned by the Marquess of Rockingham to be an equestrian portrait of King George III, and to hang as a pair to another of George II by the Swiss artist David Morier, which Rockingham already owned. Stubbs, the leading horse painter of his day, was to paint Whistlejacket, the prize stallion of Rockingham's stables, and the figure and background were to be added by other artists. But legend has it that on the day when Whistlejacket was being held by a stable boy for a final painting session, an extraordinary thing

happened. The horse, who was famously unmanageable, caught sight of the painting and, taking it for a real horse, tried to attack it, 'till at length the horse reared up his head and lifted the boy quite up from the ground; upon which he began beating him over the face with a switch stick, and Stubbs likewise got up and frightened him with his palette and Mahlstick till the animal . . . became confused and suffered himself to be led quietly away.' When he learned of the incident, the marquess took it as proof of the painting's excellence and decided that no more should be done to it.

There may have been other reasons. Horace Walpole said that Rockingham abandoned the idea of an equestrian portrait of George III for political reasons, when he 'went into opposition'. Or he may just have decided that Stubbs's horse was too lifelike for the painting to form a satisfactory pair with Morier's more pedestrian effort. Whatever the

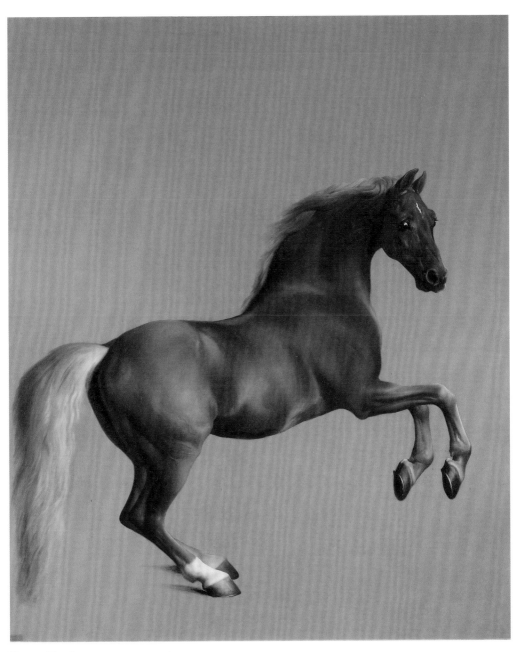

Thoroughbred

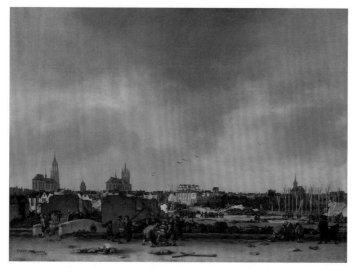

Thunderclap

truth, there is no trace of a rider or of any harness in the painting. Whistlejacket is allowed to command the canvas in splendid isolation.

▶ SEE ANATOMY, RHINOCEROS

Thunderclap

EGBERT VAN DER POEL, A VIEW OF DELFT AFTER THE EXPLOSION OF 1654, 1654

Where are we? Baghdad perhaps, Kabul, Beirut? The devastated cityscape with its fallen masonry and blasted trees seems horribly familiar. But this is one of the most picturesque cities of the Netherlands – Delft – which on 12 October 1654 suffered a devastating explosion that destroyed a quarter of the city. At just after 11.30 am on a typical Monday morning, as the people of Delft went about their daily business, Cornelis Soetens, the keeper of a gunpowder store housed in an old convent, entered the magazine. There followed five

almost simultaneous explosions as 90,000 lbs of gunpowder went up. The blast could be heard over 150 kms away and became known as the Delft Thunderclap. Over a hundred people were killed and many thousands injured. Some people believed that it was a judgement from God; one Protestant accused the city authorities of being too tolerant of Catholics.

The painter van der Poel went on to record the event in over 20 pictures, of which this is the best known. To the right, a water-filled crater marks the spot where the gunpowder had been stored. The surrounding buildings have been reduced to rubble and in the foreground people are busy helping the wounded and comforting one another. Among the dead was van der Poel's own son, which perhaps explains his obsession with the subject. But, for posterity, the greatest loss was the painter Carel Fabritius, Rembrandt's

most gifted pupil, who died aged
only 32.

▶ SEE DISTORTION, MARTIAL ART, PATIENCE
AND MEEKNESS

Toddlers

ANTHONY VAN DYCK, CHARITY, ABOUT
1627–8 (LEFT)
SIR JOSHUA REYNOLDS, LADY COCKBURN
AND HER THREE ELDEST SONS, 1773 (RIGHT)

Reynold's image of an aristocratic lady
being overwhelmed by her scantily-clad
boys looks faintly comic – you can
picture the troop of maids on hand to
take the noisy brood off to the nursery
as soon as the sitting is over. Reynolds
must have been very patient as he held
several separate sittings with each of the
three boys – all of whom were under

three years old at the time.

When this group portrait was painted,
in 1773, motherhood had become newly
fashionable, mostly because of the
writings of the French philosopher
Jean-Jacques Rousseau. Lady Cockburn
is presented as the embodiment of
motherly care, literally supporting her
children. All the more appropriate,
therefore, that Reynolds turned to an
allegorical painting of *Charity* by Van
Dyck as the model for his composition.
In this picture, three infants also swarm
over a motherly figure amid a swirl of
red drapery, against a blue sky streaked
with clouds. Reynolds took the pose
of the boy kneeling on the left from
a cupid in another National Gallery
picture, Velázquez's *'Rokeby Venus'*.

▶ SEE FASHIONABLY LATE, SISTERS

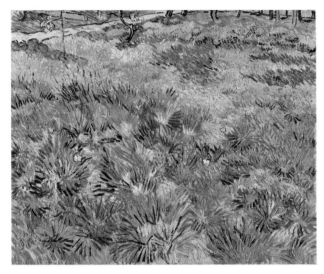

Topsy-Turvy

VINCENT VAN GOGH, LONG GRASS WITH
BUTTERFLIES, 1890

One day in 1965, a 15-year-old
schoolgirl inadvertently succeeded in
making the National Gallery's experts
look very foolish. Visiting the Gallery
on a school trip, she was especially
keen to see the works of Van Gogh,
her favourite artist. To her surprise
she found that one, *Long Grass with
Butterflies*, was hanging upside down.
Admittedly, as a landscape this painting
is far from conventional. The surface
is a dense network of brushstrokes and
there is no horizon. But surely the
National Gallery should have known
which way up to hang a Van Gogh,
even one as formless as this. When the
girl told the chief attendant, he was
dismissive: 'Oh, and how do you
know?' She was insistent, so he went
to get a postcard to compare with the
picture. Then another attendant

intervened: 'Yes, sir, I think it is upside
down.' Apparently *Long Grass with
Butterflies* had been taken down to be
photographed and only just been put
back the wrong way up. How many
people puzzled over the painting we
do not know, but it took a keen-eyed
teenager to spot the mistake.

▶ SEE CHAIRS, MODERN ART

Tragic Consequences

J.M.W. TURNER, DIDO BUILDING CARTHAGE, 1815

Kneeling in the foreground of Turner's
painting of *Dido building Carthage*, four
boys watch as their toy boat sails off
into the stream. This little detail is too
conspicuous not to have any meaning.
Turner has placed it there to point to
the tragic outcome of the story of Dido
and Aeneas. Dido, Queen of Carthage,
fled Tyre after the murder of her
husband Sichaeus and arrives by sea to
the coast of Africa, where she establishes

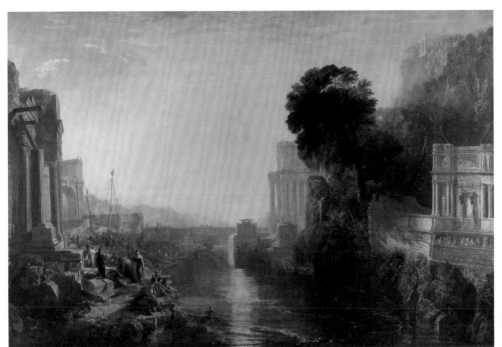

the city of Carthage. Aeneas, fleeing the sack of Troy, is shipwrecked on her shores and they fall in love. However, Aeneas is destined to be the founder of Rome and, urged by the gods, he abandons Dido, who in despair kills herself. Aeneas's deception and its tragic consequences were traditionally seen as the origin of the hostility between Carthage and Rome, which ultimately led to the Punic Wars and the destruction of Carthage. This painting purports to show the rise of Carthage as a great city and capital of a maritime empire. Dido appears on the left in white directing her architects, and the helmeted figure in front of her with his back to us may be Aeneas. As a pair to this, Turner painted another picture,

The Decline of the Carthaginian Empire, which shows a defeated Carthage, but here already there are forebodings of impending disaster. The emerging city with its unfinished buildings can be interpreted as a city half in ruins. On the right, across the water is the tomb of Sichaeus with, at its base, a relief depicting his murder at the hands of his brother-in-law. He was the victim of deceit. By falling in love with Aeneas, Dido has in a sense also betrayed him, as Aeneas will deceive her. The toy boat sailing out into the sunset prefigures this deceit and anticipates the moment when, breaking his love vows, Aeneas departs for Italy and abandons the queen to her fate.

▶ SEE LAST VOYAGE, RACE

Tricoleur

Tricoleur

JEAN-FRANÇOIS MILLET, THE WINNOWER,
ABOUT 1847–8

It is no coincidence that the red, white and blue of the winnower's clothing in Millet's painting are the colours of the French republican flag, the *drapeau tricolore*. He painted it just after the Revolution of 1848, which deposed King Louis-Philippe and ushered in a republican government. When it was shown at the 1848 Salon exhibition, the critic Théophile Gautier wrote, 'Nothing could be more rugged, ferocious, bristling and crude. M. Millet's painting has everything it takes to horrify the bourgeois.' In the anonymous winnower, his feet and hands red and swollen with physical effort, Millet expressed his sympathy with the labouring classes. The work of the winnower is an expression of change, of the grain of new life being separated from the chaff. The painting caught the mood of the time and was purchased from the Salon by Alexandre Auguste Ledru-Rollin, the Minister of the Interior of the New Republic, who was responsible for introducing a system of universal suffrage in France. But within a year, Napoleon III had seized power, Ledru-Rollin had fled to London, and the painting was sold. It found its way to America where there was greater sympathy for the artist and his ideals, but soon disappeared from view, a casualty, it was long thought, of the Boston fire of 1872. A century passed before it was rediscovered in an attic, filthy but intact, and still in its original frame, stamped with the number under which it was registered at the Salon of 1848. It was bought by the National Gallery in a New York sale in 1978.

▶ SEE CENSORSHIP

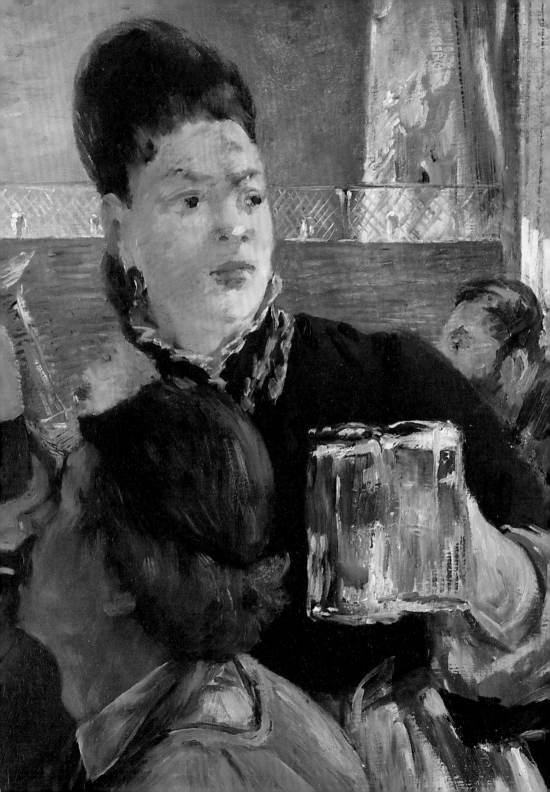

U, V & W

Ugly Duchess, Vision, Wagon Wheels…

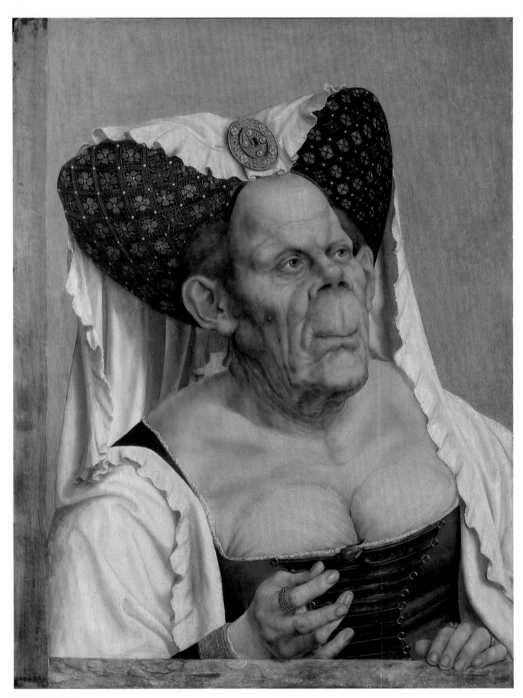

Ugly Duchess

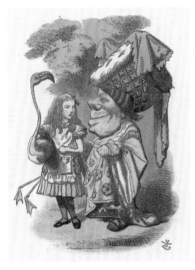

Ugly Duchess

Ugly Duchess

QUINTON MASSYS, A GROTESQUE OLD WOMAN, ABOUT 1525–30

This painting of an old woman is quite shocking in its cruelty and it's difficult to understand why Massys painted it. Was this woman really this ugly? Was she ill? Is Massys's painting an invention, or a copy of another picture?

Some people think that the woman in the picture had Paget's Disease, an illness that deforms the bones of the face. For a long time the picture was thought to be a portrait of the fourteenth-century Duchess Margaret of Tyrol, who was noted as the ugliest woman in history, and nicknamed '*Maltasche*' or 'pocket-mouthed' after her enormous mouth. Another print names her as the Queen of Tunis, but both identifications are unproven. The portrait, or one of its many versions, was Sir John Tenniel's inspiration for the Ugly Duchess in Lewis Carroll's *Alice's Adventures in Wonderland*

(above). Carroll describes the Duchess as 'very ugly', but apart from a reference to her pointed chin, that is all that he tells us of her appearance.

▶ SEE POETIC LICENCE, RELUCTANT SITTER

Vision

ODILON REDON, OPHELIA AMONG THE FLOWERS, ABOUT 1905–8

The drowning Ophelia from Shakespeare's *Hamlet* was a popular subject in nineteenth-century art. Redon's treatment is unusual in that his Ophelia does not seem to be garlanded with flowers, as Shakespeare describes, but contemplating with closed eyes a burgeoning festoon of them. The reason for this may be that the subject wasn't premeditated and the pastel began life as a simple flower piece. At the time he made it, when he was in his mid-sixties, pastels of garden flowers in vases, drawn in unnaturally vivid

Vision

colours, were a favourite subject of Redon's. His wife would gather the blooms and arrange them for him. If you look at *Ophelia* on its side, with the brown strip at the bottom, it is possible to make out an arrangement of flowers in a blue vase on a brown table top, with an orange background. The drawing that describes Ophelia's head has been added on top of this background. So too has the dark blue-black area in the bottom left-hand corner giving an impression of water, and the black and brown shading that turns the vase and table top into a rocky landscape. Seeing the possibility of a new subject, Redon must have turned his pastel study of flowers on its side and transformed it into the composition that we now see, with Shakespeare's heroine as a type of visionary who, with closed eyes, perceives a beauty that transcends everyday reality.

▶ SEE SKULL

Wagon Wheels

JOHN CONSTABLE, THE HAY WAIN, 1821

What is going on in *The Hay Wain*? Every feature of Constable's famous painting is etched into popular memory – the horse-drawn wagon, Willy Lott's cottage at the left, the distant hay makers, the dog on the bank, the light-filled sky – but why is the wagon stranded in mid-stream, apparently going nowhere? A countryman wrote to the Gallery suggesting an answer. He remembered that when he was a boy wagons were driven into streams or ponds in the heat of the summer to soak the wooden wheels, so that the joints did not dry out and become loose.

In *The Hay Wain* Constable painted a picture of a particular way of life that was at the time rarely recorded in art with such accuracy – he was documenting a way of life he knew well. One of the reasons Constable's contemporaries bought his pictures was because they

recognised this quality. It may help to explain what we in the twenty-first century like about them as well.

▶ SEE LAST VOYAGE, RACE

Waitress

EDOUARD MANET, CORNER OF A CAFÉ-CONCERT, PROBABLY 1878–80

The tell-tale vertical line through the smock of the young man in Manet's *Corner of a Café-Concert* is a clue to an extraordinary tale of second thoughts and revisions. Manet's painting began life as part of a larger picture of a café scene and showed to the left two women and a man seated on the other side of the marble-topped table. This part of the picture survives as a separate painting, *At the Café*, in Switzerland

(p. 165, overleaf), and when the two halves were examined side by side, the shadows of the glasses on the table matched exactly, proving they were once joined. Part of the hand of a woman in the left part can even be seen at the edge of the London painting. But the background of the Swiss picture shows a café window, not the stage and orchestra we see in the London picture. We know through technical examination that the same window did indeed continue into the London picture, but was painted over with the background we see now, in a quite different, Impressionist technique of broken strokes and dabs of paint. But why is there a line through the blue blouse? This was probably the original right edge of the larger painting, but

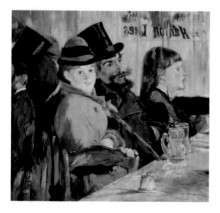

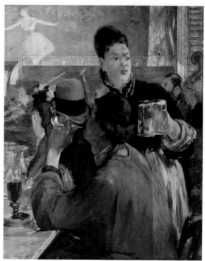

Waitress

when Manet cut it in two, he decided to extend the right part, adding a strip of canvas along the right edge so that the waitress would be more central to the composition. He used thinner paint for the additional strip of blue blouse so that, while it may have matched the rest when it was first painted, it has changed over the years to provide a clue to the picture's convoluted origins.

▶ SEE CENSORSHIP, LOWERING THE TONE, STRIPTEASE

Work-Life Balance
JUDITH LEYSTER, A BOY AND A GIRL WITH A CAT AND AN EEL, ABOUT 1635

Balancing a career with the demands of a family is not a problem exclusive to women in the modern world. Leyster was a successful painter working in Haarlem in the 1620s and 1630s, employing at one point at least three male apprentices (one of whom left her studio to work for Frans Hals). But in 1636 she married Jan Molenaer, a rather less talented artist, and all but gave up painting to care for him and their five children. Some people have detected an inexplicable improvement in the quality of Molenaer's work from the time of his marriage to Leyster. Maybe it was her skill as an artist that made her an attractive marriage prospect. Perhaps she did not stop painting after all, but was obliged to support her husband as more than just a wife and mother.

This painting seems to be a visual representation of the Dutch saying: 'He who plays with cats gets scratched', – meaning, if you look for trouble you will probably find it. The boy has used the eel to trap the cat in his arms while the girl pulls its tail. But if you look closely at the cat's claws, you can see that it is about to scratch the boy, so he will get what he deserves.

▶ SEE HERO WORSHIP, SKULL

Work-Life Balance

X,Y & Z

X-ray, Yarn, Zealot …

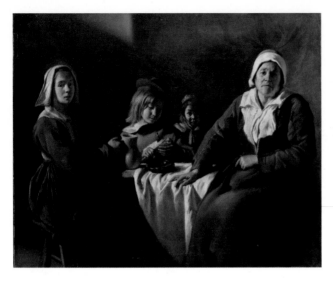

X-Ray

LE NAIN BROTHERS, FOUR FIGURES AT A TABLE, ABOUT 1643

X-ray examination is an invaluable tool in the study of paintings. By revealing layers of paint beneath the visible surface, it can show how a painting evolved over the course of the artist's work and, occasionally, it can reveal another painting altogether. Such is the case with *Four Figures at a Table*, a seventeenth-century work by one of the Le Nain brothers. The streaky area of background above the head of the elderly woman on the right was thought to represent a curtain, but when the painting was X-rayed in 1978 it was found that there was a complete bust-length portrait of a man underneath and what had been supposed to be a curtain was in fact the folds of his doublet showing through. Because much of this portrait is painted in light colours containing lead white, which registers well in X-rays, and as there is relatively little lead white in the painting of *Four Figures*, the X-ray image (above) is remarkably clear and detailed. The pigments were also identified, so we can deduce a great deal about the man's appearance. He has dark hair and a goatee beard, a starched white ruff with a red tassel, and his doublet is pale grey with gold or yellow braiding. The style of the dress suggests a date in the 1620s or 1630s, perhaps a decade earlier than *Four Figures*. Who painted it and why was the canvas reused? It is probable that the portrait is also the work of one of the Le Nain brothers, but we will never know why it was discarded. Although the Le Nains' early reputation was largely dependent on their work as portrait painters, very few examples have survived, which makes this ghostly presence all the more significant.

▶ SEE BROTHERS

Yarn
HENRI ROUSSEAU, SURPRISED!, 1891

Rousseau, a minor inspector in a Paris toll collector's office and an amateur painter, drew on his memories of military service in the ill-fated French Expeditionary Force to Mexico when he painted his jungle pictures. Or so he would have us believe. In fact, during the four years he spent in the army from 1863 he never left France, and the circumstances of his life were distinctly un-exotic. Rousseau needed to be a fantasist to concoct his jungle pictures, with their unlikely cast of explorers, cyclists, snake charmers, monkeys and wild beasts. His pictorial world is a feat of imagination nourished by soldiers' tales, popular fiction, art and natural history. The tiger in *Surprised!* was inspired by a print after a painting by Delacroix. The plants are copied and enlarged from books and from specimens in the Jardin des Plantes in Paris. Rousseau wrote, 'When I go into the glass houses and I see the strange plants of exotic lands, it seems to me that I enter into a dream.'

▶ SEE CENSORSHIP, PATIENCE AND MEEKNESS, UGLY DUCHESS

Zealot

Zealot

FLORENTINE ARTIST, PORTRAIT OF SAVONAROLA, PROBABLY ABOUT 1500–40

A panel in the National Gallery by an unknown Florentine painter bears witness to a remarkable character whose preaching led to the destruction of much Renaissance art, including, it is said, paintings by Botticelli and Michelangelo.

Girolamo Savonarola was a Dominican preacher who became Prior of the convent of San Marco in Florence in 1491. There he prophesied that the end of the world was nigh. He also preached that the suffering caused by the French invasions and the spread of syphilis were the judgement of God on the wrongdoings and moral laxity of the people of Florence. With the expulsion of the ruling Medici family, Savonarola consolidated his power, and like many religious zealots before and since, imposed a rule of ruthless intolerance. Taverns were closed, gambling and swearing banned, homosexuality made punishable by death, and in 1497 a massive bonfire – the Bonfire of the Vanities – was lit in the Piazza della Signoria, onto which were cast items associated with moral laxity – mirrors, cosmetics, lewd pictures and sculptures, works by the ancient poets, musical instruments, fine clothes and gaming tables. In his enthusiasm, the painter Botticelli is said to have even cast his own paintings of pagan subjects into the flames.

But just as there seemed to be no respite in the suffering of the Florentines, opinion turned against the preacher. On 13 May 1497 Savonarola was excommunicated by Pope Alexander VI, declared a heretic, and the following year, he was arrested. His fate is depicted on the reverse side of the portrait. On 23 May 1498, having been tortured on the rack, Savonarola and his two closest associates were hung in chains from a single cross and burnt – on the site of the Bonfire of the Vanities.

▶ SEE APOCALYPSE, SYPHILIS

Index of Artists

B

Bassano, Jacopo (died 1592) **48–9**
Bellini, Gentile (died 1507) **20–1**
Bellini, Giovanni (died 1516) 88
Bermejo, Bartolomé (about 1440–after 1495) **93–4**
Bonheur, Rosa (1822–1899) **11–12**
Botticelli, Sandro (about 1445–1510) **15–17, 116–17, 172**
Bouts, Dirk (1400?–1475) **56–57**
Bronzino (1503–1572) **149**
Brueghel the Elder, Jan (1568–1625) **58**

C

Campin, Robert, Follower of **32**
Caravaggio, Michelangelo Merisi da (1571–1610) **49–50, 142**
Cézanne, Paul (1839–1906) **6, 31, 84, 145–6**
Champaigne, Philippe de (1602–1674) **109**
Cima da Conegliano, Giovanni Battista (about 1459/60–about 1517/8) **6, 142–4**
Claude (1604/5?–1682) **6, 60, 102**
Coques, Gonzales (1614/8–1684) **140–1**
Constable, John (1776–1837) **50, 61, 164–5**
Courbet, Gustave (1819–1877) **124**
Crivelli, Carlo (about 1430/5–about 1494) **64, 67, 116**

D

Daubigny, Charles-François (1817–1878) **50–52**
Degas, Hilaire-Germain-Edgar (1834–1917) **27–8, 65, 87, 129–30**
Delacroix, Eugène (1798–1863) **87, 171**
Delaroche, Paul (1797–1856) **31–2**
Dou, Gerrit (1613–1675) **79–80**
Drouais, François-Hubert (1727–1775) **120–3**

E

English or French (?) (late 14th Century) **115–16**
Eyck, Jan van (active 1422–1441) **46–8, 85**

F

Fabritius, Carel (1622–1654) **41–2, 102–3, 154–5**

G

Gainsborough, Thomas (1727–1788) **26–7, 38–40, 141–2**
Geertgen tot Sint Jans (about 1455/65–about 1485/95) **97**
Giotto di Bondone, attributed to (1266/7–1337) **6, 64–5, 73**
Gogh, Vincent van (1853–1890) **4, 6, 22, 28–30, 156**

H

Hals, Frans (about 1580?–1666) **142, 166**
Heyden, Jan van der (1637–1712) **10**
Hogarth, William (1697–1764) **38**
Holbein the Younger, Hans (1497/8–1543) **12–14, 63, 78, 136–7**
Hooch, Pieter de (1629–1684) **117, 119–120**

I

Ingres, Jean-Auguste-Dominique (1780–1867) **58–60, 87**
Italian (early twentieth century) **57**
Italian, Florentine **172**
Italian, Umbrian (?) **7, 133–4**

L

Lawrence, Sir Thomas (1769–1830) **130–2**
Le Nain, Antoine (about 1600–1648) **7, 23, 170**
Le Nain, Louis (about 1603–1648) **7, 23, 170**
Le Nain, Mathieu (about 1607–1677) **7, 23, 170**
Leonardo da Vinci (1452–1519) **4, 7, 26, 37**
Leyster, Judith (1609–1660) **166**
Lippi, Fra Filippo (about 1406–1469) **103–5**
Longhi, Pietro (1700/2–1785) **134–6**
Lotto, Lorenzo (about 1480–1556/7) **64, 70, 136–7**

M

Manet, Edouard (1832–1883) **6, 27–8, 87, 98–9, 133, 165–6**
Mantegna, Andrea (about 1430/1–1506) **14–15, 57, 88**
Massys, Quinton (1465–1530) **163**
Matisse, Henri (1869–1954) **52**
Menzel, Adolph (1815–1905) **98–9**
Micas, Nathalie (about 1824–1899) **11–12**
Michelangelo (1475–1564) **98, 111**
Mignard, Pierre (1612–1695) **30–1**
Millet, Jean-François (1814–1875) **159**
Monet, Claude (1840–1926) **50–2, 63–4, 81, 133**
Mornauer Portrait, Master of the (active about 1460–1514) **78**
Moroni, Giovanni Battista (1520/4–1579) **42–3**

O

Orioli, Pietro (1458–1496) **65–6**

P

Parmigianino (1503–1540) **147–9**
Pesellino, Francesco (about 1422–1457) **103–5**
Piero di Cosimo (about 1462–after 1515) **46**
Pissarro, Camille (1830–1903) **50–2**
Poel, Egbert van der (1621–1664) **154–5**
Pollaiuolo, Piero del (about 1441– before 1496) **140**
Antonio de (about 1432–1498) **140**
Pontormo (1494–1557) **144–5**
Previtali, Andrea (about 1480–1528) **107**

R

Raphael (1483–1520) **7, 20, 71, 72–3, 84, 111**
Redon, Odilon (1840–1916) **163, 164**
Rembrandt (1606–1669) **6, 10, 22, 71, 97, 103, 114, 155**
Reni, Guido (1575–1642) **11**
Renoir, Pierre-Auguste (1841–1919) **63, 84, 107, 108**
Reynolds, Sir Joshua (1723–1792) **26, 155**
Rosa, Salvator (1615–1673) **146**
Rousseau, Henri (1844–1910) **171**
Rubens, Peter Paul (1577–1640) **40–1, 78–9, 92, 128**

S

Saenredam, Pieter (1597–1665) **73–4**
Sebastiano del Piombo (about 1485–1547) **111, 137**
Strozzi, Zanobi, attributed to (1412–1468) **123–4**
Stubbs, George (1724–1806) **152**
Swabian (fifteenth Century) **64–5**

T

Titian (active about 1506–1576) **6, 48–9, 71, 132**
Turner, Joseph Mallord William (1775–1851) **50, 95–6, 128–9, 156–7**

U

Uccello, Paolo (about 1397–1475) **74–5, 125**

V

Velázquez, Diego (1599–1660) **4, 109–10, 133, 155**
Vigée Le Brun, Elizabeth Louise (1755–1842) **78–9**

W

Wright of Derby, Joseph (1734–1797) **119**

Z

Zoffany, Johann (1733?–1810) **120–2**

Index of Paintings

A

The Abduction of Helen, about 1450–5 **123**
The Adoration of the Kings, 1598 **58**
The Adoration of the Shepherds, about 1640 **11**
Afternoon in the Tuileries Gardens, 1867 **98**
The Agony in the Garden, about 1460 (Mantegna) **88**
The Agony in the Garden, about 1465 (Bellini) **88**
An Allegory, probably about 1490–1550 **116**
An Allegory with Venus and Cupid, probably
 1540–50 **149**
'The Ambassadors', 1533 **137**
Angelica saved by Ruggiero, **1819–39 87**
The Arnolfini Portrait, 1434 **46**

B

Bathers at La Grenouillère, 1869 **63**
Bathers (Les Grandes Baigneuses), about 1894–1905
 145
The Battle of San Romano, probably about 1438–40 **125**
The Beach at Trouville, 1870 **81**
Belshazzar's Feast, about 1635 **114**
A Boy and a Girl with a Cat and an Eel, about 1635 **166**

C

Cardinal Bessarion with the Bessarion Reliquary,
 about 1472–3 **20**
Charity, about 1627–8 **155**
Christ in the House of Martha and Mary,
 probably 1618 **109**
Christina of Denmark, Duchess of Milan, 1538 **12**
Combing the Hair ('La Coiffure'), about 1896 **129**
Corner of a Café-Concert, about 1878–80 **165**
The Courtyard of a House in Delft, 1658 **117**

D

The Demidoff Altarpiece, 1476 **67**
Dido building Carthage, 1815 **156**
Diptych, about 1260 **133**
Dr Ralph Schomberg, 1770 **38**

E

'The Enchanted Castle', 1664 **102**
The Entombment, probably 1450s (Bouts) **56**
The Entombment, 1500–1 (Michelangelo) **98**
The Execution of Lady Jane Grey, 1833 **31**
The Execution of Maximilian, about 1867–8 **27**
Exhibition of a Rhinoceros at Venice,
 probably 1751 **134**
An Experiment on a Bird in the Air Pump,
 1768 **119**

F

The Fighting Temeraire, 1839 **95**
Four Figures at a Table, about 1643 **170**
Fox Hill, Upper Norwood, 1870 **50**

G

Giovanni Agostino della Torre and his Son, Niccolò,
 about 1513–16 **70**
The Graham Children, 1742 **38**
A Grotesque Old Woman, about 1525–30 **163**

H

The Hay Wain, 1821 **164**
The Horse Fair, 1855 **11**

I

The Incredulity of Saint Thomas, about 1502–4 **142**
The Interior of the Buurkerk at Utrecht, 1644 **73**
The Introduction of the Cult of Cybele at Rome,
 1505–6 **14**

K

A Knight with his Jousting Helmet, about 1554–8 **42**

J

Joseph with Jacob in Egypt, probably 1518 **144**

L

Lady Cockburn and her Three Eldest Sons, 1773 **155**
A Lady with a Squirrel and a Starling (Anne Lovell?),
 about 1526–8 **63**
Landscape with Hagar and the Angel, 1646 **60**
Long Grass with Butterflies, 1890 **156**

M

Madame de Pompadour at her Tambour Frame,
 1763–4 **122**
Madame Moitessier, 1856 **58**
The Madonna and Child with Saints, 1526–7 **147**
The Madonna of the Pinks, 1511 **72**
Man with Quilted Sleeve, about 1510 **71**
Margaretha de Geer, Wife of Jacob Trip, 1661 **22**
The Marquise de Seignelay and Two of her Sons,
 1691 **30**
The Martyrdom of Saint Sebastian, completed
 1475 **140**
Mrs Oswald, about 1763–4 **120**
Mrs Siddons, 1785 **26**
Music in the Tuileries Gardens, 1862 **98**
'Mystic Nativity', 1500 **15**

N
The Nativity at Night, possibly about 1490 **97**
The Nativity with Saints, probably about 1485–95 **65**

O
Ophelia among the Flowers, about 1905–8 **163**

P
The Painter's Daughters chasing a Butterfly, probably about 1756 **141**
The Painter's Daughters with a Cat, 1760–1 **141**
Peace and War, 1629–30 **40**
Pentecost, about 1306–12 **73**
Philip IV of Spain, about 1631–2 **133**
The Pistoia Santa Trinità Altarpiece, between 1455 and 1460 **103**
Pope Julius II, 1511 **20**
Portrait of Alexander Mornauer, about 1464–88 **78**
Portrait of a Man (Self Portrait?), 1433 **85**
Portrait of a Woman as Saint Agnes, about 1680 **140**
Portrait of a Woman of the Hofer Family, about 1470 **64**
Portrait of Giovanni della Volta with his Wife and Children, completed 1547 **136**
Portrait of Greta Moll, 1908 **52**
Portrait Group, early twentieth century **57**
Portrait of Savonarola, perhaps about 1500–40 **172**
Portrait of Susanna Lunden (?) ('Le Chapeau de Paille'), probably 1622–5 **78**
Portrait of the Archduke Albert, before 1615 **128**
Portrait of the Infanta Isabella, before 1615 **128**
A Poulterer's Shop, about 1670 **79**
The Purification of the Temple, probably about 1580 **48**

Q
Queen Charlotte, 1789 **130**

R
Rain, Steam and Speed – The Great Western Railway, before 1844 **128**
The Raising of Lazarus, about 1517–19 **111**

S
Saint George and the Dragon, about 1470 **74**
Saint Michael Triumphs over the Devil, 1468
Salome receives the Head of Saint John the Baptist, 1607–10 **49**

A Satyr mourning over a Nymph, about 1495 **46**
Scenes from Tebaldeo's Eclogues, perhaps about 1505 **107**
Self Portrait, about 1645 (Rosa) **146**
Self Portrait at the Age of 34, 1640 (Rembrandt) **71**
Self Portrait in a Straw Hat, after 1782 (Vigée Le Brun) **78**
A Shepherd with his Flock in a Woody Landscape, 1615–22
The Skiff (La Yole), 1875 **107**
St Paul's from the Surrey Side, 1873 **50**
Still Life with Apples and a Pomegranate, 1871–2 **124**
Surprised!, 1891 **171**

T
The Thames below Westminster, about 1871 **50**
Three Men and a Boy, about 1647–8 **23**
Triple Portrait of Cardinal de Richelieu, probably 1642 **109**

U
The Umbrellas, about 1881–6 **84**

V
Van Gogh's Chair, 1888 **28**
The Vendramin Family, mid-1540s **132**
Venus and Mars, about 1485 **116**
View of the Westerkerk, Amsterdam, probably 1660 **10**
A View of Delft after the Explosion of 1654, 1654 **154**
A View of Delft, with a Musical Instrument Seller's Stall, 1652 **41**
The Virgin and Child before a Firescreen, about 1440 **32**
The Virgin and Child with Saint Anne and Saint John the Baptist, about 1499–1500 **26**
The Virgin of the Rocks, about 1491–1508 **37**

W
'The Watering Place', 1615–22 **92**
Whistlejacket, about 1762 **152**
The Wilton Diptych, about 1395–9 **115**
The Winnower, about 1847–8 **159**
A Woman drinking with Two Men, probably 1658 **119**

Y
Young Man holding a Skull (Vanitas), 1626–8 **142**
Young Man in a Fur Cap, 1654 **102**